towards an engaged gallery

Contemporary art and human rights:
GoMA's social justice programmes

Katie Bruce • Victoria Hollows

with

Ben Harman • Alicia Watson

First published in 2007 by Culture & Sport Glasgow (Museums).

ISBN 978-0-902752-88-7

Authors: Katie Bruce, Ben Harman, Victoria Hollows, Alicia Watson

Edited by: Susan Pacitti and Vivien Hamilton

Designer: John Westwell

Printed in Scotland by Allander.

www.glasgowmuseums.com

Contents

Foreword

The Gallery of Modern Art (GoMA) opened in 1996 and quickly established itself as a member of the city's family of museums, and part of the unique Glasgow tradition of museum visiting. GoMA now receives over 500,000 visits a year, a level of visitation achieved without any corresponding reduction in visits to other museums across the city. This level of support means that it is the most-visited contemporary art museum in Britain outside London, a fact that is perhaps all the more surprising given the challenging programme that it mounts. Its exhibition policy includes a range of elements, but the central, distinguishing feature is the *Contemporary Art and Human Rights* programme. This began in 2001 with a commitment from Glasgow City Council to fund three biennial exhibitions on human rights themes: asylum seekers and refugees (*Sanctuary*, 2003); violence against women (*Rule of Thumb*, 2005); and sectarianism (*Blind Faith*, 2007). Each of these exhibitions was to be accompanied by a citywide community engagement strategy, with the objective that both exhibition and community engagement process would be of international quality.

There were initial concerns that programming on these themes might constrain artists or generate agit-prop art. But it quickly transpired that artists are – of course – as concerned as anyone else about the great humanitarian issues of our time, and address it in their art. We have had no difficulty in soliciting the involvement of major artists from Scotland and overseas, so that the distinguishing features of the exhibitions are their quality and variety of form and style.

Now that the first three major programmes are complete, or nearly so, the time has come to take stock. What have we learned from the experience of engaging with three very different issues – and with three very different communities of interest? While the projects were very particular, were there general trends from which we, and perhaps others, could learn? We hope that this book will provide a valuable record of these invaluable projects, bring back happy memories of fulfilment to those involved as participants or observers, and provide others with an opportunity to learn from our successes – and our mistakes.

Liz Cameron
Chair, Culture & Sport Glasgow

Who's Who

Claire Atkinson
Rule of Thumb advisory board member
Amnesty International Scotland – one of our main partners for *Sanctuary* and *Rule of Thumb*

Jennifer Beattie
Web designer for the Calendar Project, a *Rule of Thumb* outreach project

Sandy Brindley
Rule of Thumb advisory board member
Rape Crisis Scotland – one of our main partners for *Rule of Thumb*

Katie Bruce
Social Inclusion Co-ordinator; lead artist for *elbowroom* Base 75 and Glasgow Women's Aid projects
GoMA

Roderick Buchanan
Artist

Madeleine Conn
Lead artist, *Rule of Thumb* North West Women's Centre outreach project

Lesley Craigie
Play therapist, *elbowroom* Red Road Women's Centre project

Naheed Cruickshank
Musician, Glasgow Women's Aid and Red Road Women's Centre *elbowroom* projects

Brian Dargo
Technician
GoMA

Janette De Haan
Training facilitator and supervisor for *elbowroom* and *Rule of Thumb* Women's Support Project

Florence Dioka
Rule of Thumb advisory board member
Meridian

William Docherty
Learning Assistant
GoMA

Alison Elliot
Rule of Thumb advisory board member
Glasgow City Council Education Department

Anne Elliot
Lead artist, *elbowroom* Base 75 and Red Road Women's Centre projects; *Rule of Thumb* 218 outreach project

Nonie Fisher
Rule of Thumb advisory board member
Rape Crisis Centre, Glasgow

Scott Fleming
AV Technician
Glasgow Museums, Culture & Sport Glasgow

Magi Gibson
Lead writer, *Rule of Thumb* Barlinnie Prison outreach project

Stuart Gordon
AV Technician
Glasgow Museums, Culture & Sport Glasgow

Belinda Guidi
Artist, *elbowroom* Glasgow Women's Library project; *Rule of Thumb* Aberlour Dependency Project outreach project; Tramway *With Drill and Bow* partner project

Carol Greig
Museum Officer
GoMA

Ben Harman
Curator, Contemporary Art
GoMA

Jo Hodges
Lead artist, *Rule of Thumb* Greater Easterhouse Women's Aid outreach project

Victoria Hollows
Museum Manager
GoMA

Euan Hunter
Artist, *Rule of Thumb* Phoenix House outreach project

Paul Kane
Press Officer
Corporate Communications, Glasgow City Council

Cath Keay
Artist, *Rule of Thumb* Phoenix House outreach project

Barbara Keenan
Marketing Officer
Communications Section, Glasgow Museums, Culture & Sport Glasgow

Isabelle Kerr
Rule of Thumb advisory board member
Glasgow Violence Against Women Partnership

Barbara Kruger
Artist

So-Young Lee
Designer
Communications Section, Glasgow Museums, Culture & Sport Glasgow

Joan Loftus
Rule of Thumb advisory board member
Wise Women

Caroline Mathieson
Rule of Thumb advisory board member
Glasgow Women's Aid

Rachel Mimiec
Lead artist, *elbowroom* Glasgow
Women's Library and Red Road
Women's Centre projects; *Rule of
Thumb* Calendar Project

Pervaze Mohammed
Artist, *Rule of Thumb* Phoenix House
outreach project

Susan McAndrew
Clerical Assistant
GoMA

Louise McDermott
Learning Assistant
Museum of Transport

Cassandra McGrogan
Film editor, *elbowroom* Base 75,
Glasgow Women's Library and Red
Road Women's Centre projects; *Rule of
Thumb* 218 outreach project

May McGurk
Learning Assistant
GoMA

Jane McInally
Artist, *Rule of Thumb* Meridian
outreach project

Nicky McKean
Costume maker, *elbowroom* Glasgow
Women's Aid project

James Mclardy
Artist, *elbowroom* Glasgow Women's
Aid project; Lead artist *Rule of Thumb*
Barlinnie Prison outreach project

Anne Marie Mullaney
Rule of Thumb advisory board member
Social Work Department, Glasgow City
Council

Jean Murphy
Rule of Thumb advisory board member
Chief Executive's Office, Glasgow City
Council

Michelle Naismith
Artist, *Rule of Thumb* 218 outreach
project

Janie Nicol
Lead artist *Rule of Thumb* SAY Women
and Young Women's Project outreach
projects

Jan Nimmo
Artist, *Rule of Thumb* 218 outreach
project

Mark O'Neill
Head of Arts and Museums, Glasgow
Museums, Culture & Sport Glasgow

Janet Paisley
Lead writer, *Rule of Thumb* Aberlour
Dependency Project

Adele Patrick
Rule of Thumb advisory board member
Glasgow Women's Library

Jaki troLove
Lead artist, *Rule of Thumb* Phoenix
House outreach project

Kevin Reid
Artist in residence
GoMA

Janice Sharp
Learning Assistant; lead artist
elbowroom Glasgow Women's Library
project
GoMA

Dianne Travers
Rule of Thumb advisory board member
Wise Women

Sandra Turner
Rule of Thumb advisory board member
Libraries, Culture & Sport Glasgow

Karen Vaughan
Artist, *elbowroom* Glasgow Women's
Library project

Aby Vulliamy
Lead musician, *Rule of Thumb*
Meridian outreach project

Alicia Watson
Education & Access Curator
GoMA

Lorraine Wilson
Visual Arts Officer
Tramway

Dawn Youll
Artist, *Rule of Thumb* Phoenix House
outreach project

Giving Elbow Room: Contemporary art and human rights

Victoria Hollows, Museum Manager, Gallery of Modern Art

SHRIEK WHEN THE PAIN HITS
DURING INTERROGATION. REACH
INTO THE DARK AGES TO FIND A
SOUND THAT IS LIQUID HORROR, A
SOUND OF THE BRINK WHERE MAN
STOPS AND THE BEAST AND
NAMELESS CRUEL FORCES BEGIN.
SCREAM WHEN YOUR LIFE IS
THREATENED. FORM A NOISE SO
TRUE THAT YOUR TORMENTOR
RECOGNIZES IT AS A VOICE THAT
LIVES IN HIS OWN THROAT. THE
TRUE SOUND TELLS HIM THAT HE
CUTS HIS FLESH WHEN HE CUTS
YOURS, THAT HE CANNOT THRIVE
AFTER HE TORTURES YOU. SCREAM
THAT HE DESTROYS ALL THE
KINDNESS IN YOU AND BLACKENS
EVERY VISION YOU COULD HAVE
SHOWN HIM.

From *Inflammatory Essays (1979–82)*
© 2007 Jenny Holzer, ARS, NY and DACS, London.

What you have just read is by prominent American artist Jenny Holzer. For more than 25 years, Holzer has presented her astringent ideas, arguments and sorrows in public places and in international exhibitions. Her medium, whether on a T-shirt, a poster, or an LED sign, is always writing. *Shriek When the Pain Hits* featured in the *Sanctuary* exhibition at the Gallery of Modern Art (GoMA) in Glasgow in 2003.

The exhibition was the centrepiece of a much larger programme of the same title that explored issues facing asylum seekers and refugees, and was the largest project addressing human rights ever undertaken by Glasgow Museums. It heralded the start of a major series of combined exhibition, outreach and education programmes delivered by GoMA, each one addressing a particular social justice issue. Through these, GoMA has developed a distinctive, integrated approach to its activities, reflecting Glasgow's commitment to artistic quality, to public engagement, and to social justice and equality.

GoMA: The background

GoMA is one of 11 museum venues run by Culture & Sport Glasgow on behalf of Glasgow City Council. Glasgow Museums is the largest civic museums service in the UK, with over three million visits made (free of charge) to its venues each year. As a city, Glasgow recognizes the vital contribution that museums can make to local life, to supporting artists, to developing cultural tourism and to alleviating the deprivation in which one third of its citizens live – by some measures the worst conditions in Western Europe. GoMA is one of the city's main museums, located in the heart of the city, and currently attracts over half a million visits a year. Like other Glasgow

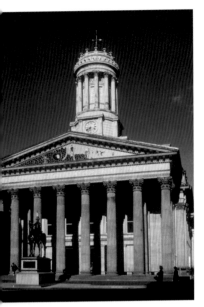

Gallery of Modern Art,
Glasgow.

Museums venues, it is reliant on Council funds raised solely from a local tax base of just 600,000 people.

From these few brief statements, we start to build a picture of the dichotomy of a large and busy city thriving on cultural industry, attracting overseas tourists and investment, set against appalling statistics for health and welfare. Glasgow has a history of being a very socially focused city; it also has an enviable reputation worldwide for the quality of its visual artists, and in parallel is increasingly recognized for the pioneering practice of its museums. Against the backdrop of the UK's Labour government drive to develop socially inclusive practices within cultural organizations, Glasgow's situation presented a potent mix for creative development.

One of Glasgow Museums' newer venues (although the building is 18th-century), GoMA first opened its doors in 1996. It was immediately successful in terms of visitor numbers, but also controversial by appearing to ignore the wealth of creative talent in Glasgow's contemporary art scene. Hailed and demonized for being populist, GoMA trod an uneasy line – loved by the public, but unloved by the art world. It also suffered from a lack of clear policies for exhibitions, education, and collections, having been initially set up to rely on a static display. This clearly was at odds with the concept of a contemporary art venue.

With a change of direction in 1999, GoMA sought to re-establish its identity by retaining the strength and support of its visitors whilst moving to a more accurate reflection of contemporary art practice, believing that these were not mutually exclusive ambitions. Over a period of two years, policies were tested and shaped to strengthen GoMA's future development and programme, identifying four key aims[1]:

- To display and interpret a wide range of the best of contemporary art, particularly that

owned by the City, to local, national and international audiences.
- To provide access to contemporary art, particularly for socially excluded groups.
- To provide an international-quality visitor attraction that contributes to Glasgow's reputation as a city of culture, promoting tourism and inward investment.
- To provide an international platform for contemporary artists working in Glasgow.

Social change

Around the same time a major social change began to affect the city. Glasgow City Council agreed to take up to 10,000 asylum seekers as part of the UK government's dispersal programme to alleviate pressure on the southeast of England. As former Lord Provost Elizabeth Cameron proudly pointed out, Glasgow has a long history of taking a global, not just a local, view of its commitments. And it is also a matter of civic pride that the vast majority of asylum seekers who are given permission to stay in the UK choose to remain in Glasgow.[2]

However, it is also acknowledged that mistakes were made when integrating these new Glaswegians into the city. Much debate ensued about the decision to house asylum seekers in areas of existing deprivation. The subsequent unrest was well documented in the media, and the public perception of asylum seekers and refugees in Glasgow was very poor. The story of Firsat Yildiz (reported in the media in 2001), a young Turkish refugee murdered in the Sighthill area of Glasgow, was a tragic indication of how far the situation had spiralled out of control.

As the impact of what was happening became clear, the Council looked to its Cultural & Leisure Services department to consider how it might develop programmes to both deliver services for asylum seekers and to encourage integration with existing Glaswegian communities. In Glasgow Museums, this role

was devolved to GoMA, with a target date of 2003 for delivery.

It is important to describe our background and how the social justice programme came about, because in all honesty, tackling such an openly political and topical issue was, at first, not something we felt comfortable with. We feared that an exhibition on this subject would look forced and prescribed. With our poor standing in the art world, who would be interested in working with us on such a project? We had concerns that this would be a backwards step in terms of our key aims for the Gallery, and that our credibility would hit rock bottom.

However, the weight of the subject strengthened the argument that GoMA was ideally placed, that contemporary art had the power through which ideas could be channelled to raise awareness of the issues for refugees and asylum seekers. The idea of a major exhibition was conceived, hand-in-hand with a vast outreach programme to work directly with new and existing communities. Not only was this responding directly to one of the Council's key social aims, but it embraced priorities established by its recent *Best Value Review* – that Glasgow Museums should reinforce its role as an agent for social change and work towards greater education provision.

Partners

By chance, Amnesty International had approached GoMA to work on a similar project on issues facing asylum seekers and refugees with their Scottish branch. After discussion, we decided to work on something much larger than we had ever attempted before. Instead of fearing this challenge, we were going to see it as an opportunity. And with support from Amnesty and the Scottish Refugee Council, we set our sights on an international-scale project to embrace this as a responsibility that reflected GoMA's, and Glasgow's, people-centred reputation. We would match it with a commitment to approach it in a way that would meet the Gallery's key aims, knitting it into our changing artistic policies.

Developing the programme

The proposed programme encompassed a development year in 2002; a large-scale six-month show for the Gallery's main summer exhibition in 2003 (already identified as central to our new programming pattern); and an 18-month outreach and education programme spanning 2002 to 2004. Cultural & Leisure Services and the wider Council quickly accepted this blueprint and soon after, it was agreed that we would tackle a different social justice issue every other year.

Glasgow City Council provided seed money for the initial programme, which enabled us to employ, on a temporary contract, a part-time Social Inclusion Co-ordinator to fundraise, develop contacts, and establish a model for the outreach programme. (Within a year, this was adopted by the Council as a full-time permanent post in Glasgow Museums' new staffing structure, which is unique to GoMA.)

The further we explored the subject, the more confident we felt about the power of art to comment in a relevant way on an internationally important contemporary subject. As Sally Daghlian, Chief Executive of the Scottish Refugee Council said, 'Art is one of the things that characterize us as human beings, and that is present in all societies in one form or another'.[3] Artists *naturally* think out of the box, working in a creative way to bring something more powerfully to our attention. This was particularly important for *Sanctuary* because it was an approach to the subject outwith the usual, more familiar media channels.

Residency

For the development year, we commissioned artist Patricia MacKinnon-Day to undertake a residency in Sighthill, one of the more notoriously deprived areas of Glasgow where

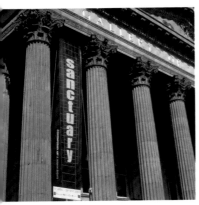

Banner for the *Sanctuary* exhibition at GoMA.

Opposite: *Real Life and How to Live It: Geography*, by Ross Sinclair, 2003. Photograph by Alan Dimmick.

asylum seekers were being housed. Her work revealed the personal histories of the people involved; the majority were highly educated professionals. The oppression many of them had endured in their own countries had forced them to leave not only their families, but also successful careers and relatively comfortable homes. This stood in direct contrast to the popular stereotype of the refugee as parasite, someone who comes to Britain to exploit its benefit systems.[4]

It was important for us to challenge the prevalence of generalizations. *Indelible*, one of the works MacKinnon-Day made during her residency, consisted of 76 black panels marked in white, each with the hand-written name and occupation of an individual. It was a succinct and powerful statement on the complexities of both a political and personal situation. The grid system referenced the framework of the Sighthill tower blocks and the harsh rigidity of every aspect of the flats' structure and layout.[5]

In other works, the artist literally deconstructed items from the packs of furniture and household objects given to each asylum seeker on arrival in Glasgow. Again, using the grid system, large-scale sculptural reliefs were formed from otherwise bland and impersonal items. These mass-produced, identical packages contain everything from basic flat-packed furniture to coat hangers, and use the cheapest possible materials. Despite their rather evocative titles (the furniture packs are labelled by the manufacturer as 'Paris Green' and 'Misty Blue'), the emphasis is on economy and practicality rather than aesthetics. Here MacKinnon-Day drew parallels between the ways in which the individual and the object are packaged and repackaged by the media and politicians, their identities and locations transformed beyond their control.[6]

Sanctuary: the exhibition

Following on from this early work, *Sanctuary* developed as a major programme with two principle aims. *Sanctuary: the exhibition*, a high-profile exhibition, would raise awareness of the plight of asylum seekers and refugees worldwide, redressing negative media portrayal and local public perception. *Sanctuary: the project* would offer our new residents access to local services afforded to other Glasgow residents, their right under the terms of Glasgow City Council's contract with central government, through a series of outreach projects. This programme attracted substantial support, with funding from the Scottish Executive, the Scottish Arts Council, the Paul Hamlyn Foundation and the Hugh Fraser Foundation.

For the exhibition we looked for artists whose practice explored human rights issues. It struck a chord. We soon found we were attracting a number of high-profile, international artists, whose passion for these subjects was a strength of their work and who welcomed the opportunity to show work within a contextualized exhibition. Their enthusiasm led many to put us in contact with other artists working in similar areas, and our fears of a politically correct, dry, forced delivery started to fade. We began to dare to think that we might just pull it off; that what was developing was strong, vibrant, relevant and heartfelt.

The works selected for this exhibition explored issues such as forced migration, displacement, torture, oppression, identity and concepts of 'home'. Thirty-four artists were featured, and between them they represented 15 different countries. Among them were names considered to be some of the most highly regarded artists in the world today, such as Bill Viola, Louise Bourgeois, Leon Golub, Hans Haacke. Some were refugee artists – Gonkar Gyatso, Saad Hirri and Zory – exhibiting for the first time, as well as key Glasgow artists, including Ross Sinclair and Graham Fagen, who would never previously

have considered exhibiting with us.

Sanctuary marked a critical change in GoMA's artistic policy, moving from its historical focus to engage with current arts practice, both in Glasgow and internationally. The exhibition included paintings, photographs, mixed media sculptures and new media works of art, and led to the overhaul of major display areas. This included the foyer, where the 600-kilogram Antony Gormley sculpture was suspended, visually linking all the *Sanctuary* exhibition spaces, including the outreach work in the balcony. We received positive acknowledgement of these changes from the art world and the press, where *Sanctuary* was cited as '... an intelligent combination of British and international artists with work which swings from the poignant to the chilling.'[7]

The exhibition opened on 9 April 2003 and ran for six months. Around 1,200 people from Glasgow's diverse cultural community attended the private view, including many of the participants from the outreach programme. We made all the information in the exhibition available in the six languages recognized as those most used in Glasgow – French, Turkish, Kurdish, Arabic, Farsi and Punjabi. We also published a catalogue as a record of the exhibition; this was the only aspect of the programme for which there was a charge.

Public reaction

Visitor figures for *Sanctuary: the exhibition* exceeded 210,000 and our annual figures have continued to grow ever since. Front-of-house staff recorded visitors from more diverse backgrounds than had previously visited GoMA, and people enquired about voluntary positions with GoMA's Volunteer Guides and the Education & Access team. A visitor survey revealed strong public support for the exhibition and the issues raised, and also indicated positive attitudinal change:

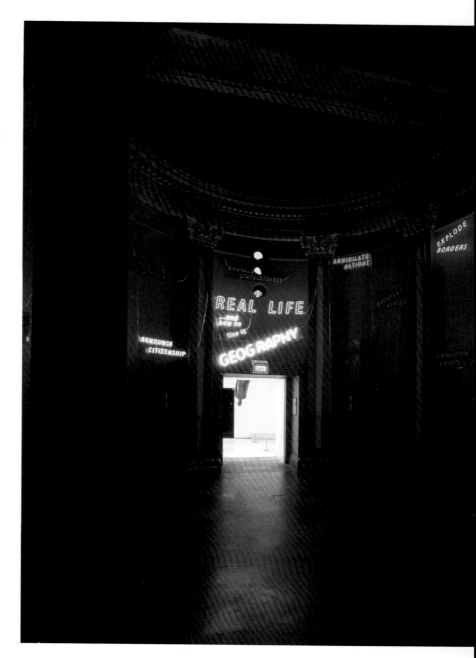

Untitled, by Louise
Bourgeois, 1998.
© DACS, London/VAGA,
New York 2007.
Photograph by Christopher
Burke.

'It is good to see the city involving everybody about the issues of immigration etc. This is helpful in sympathizing with and understanding these situations, instead of ignoring them. Helps deal with them in a positive way.'

'We all live in comfort, oblivious to these things,and it is good to see somewhere not afraid to talk about them.'

'I am politically aware and have a focus on world events as a participant in many areas through my employment with the Royal Navy. This has brought me a new viewpoint.'

'It has been very upsetting but powerful and needed. So much out today has no content.'

'Shock, anger, horror, despair, hope, inspiration and admiration.'

Supportive comments were also received regarding our plans to make this a biennial event.[8]

In addition to the main exhibition, there was a smaller, separate selling exhibition in GoMA, which raised funds for Amnesty International and the Scottish Refugee Council.

Sanctuary: the project

Whilst *Sanctuary: the exhibition* brought major international works together to highlight the power and relevance of contemporary art in dealing with global political issues, *Sanctuary*'s outreach programme used the arts to explore and highlight the issues facing people from other countries coming to live in Glasgow.

A number of agencies, projects and drop-in centres had appeared across Glasgow to assist people facing a new city, a new culture, a new bureaucracy and a new uncertainty. Katie Bruce, GoMA's Social Inclusion Co-ordinator, worked with these organizations to implement an ambitious outreach programme. Between October 2002 and February 2004, 18 contemporary artists ran 130 visual art workshops with 14 different projects supporting the 'new Glaswegians', resulting in a series of exhibitions.

By advertising through leaflets produced in six key languages and by contacting associated organizations, these workshops attracted over 300 people aged between three and over 60 from more than 20 countries. Many participants were able to attend a complete block of six or 12 workshops, and created new work which was exhibited alongside the major exhibition and across the city.

The workshops were developed to meet the needs of the various participants in conjunction with Glasgow-based contemporary visual artists and took place in accessible venues, local to where people lived. This was important, as participants were often vulnerable, unfamiliar with the city and there were issues surrounding travel, childcare and languages. (Transport costs, crèche facilities and interpreters were provided when requested.)

The legacy

Some of the benefits from this aspect of the programme on the surface seemed to be quite simple, but were in fact incredibly affecting and powerful. For instance, people attending drop-in centres for the arts activities began to access other services provided there, such as health care and banking. Men, who often remain very distant within the new communities, began to socialize and contribute as a group; young mothers, typically amongst the most isolated, began to meet regularly, and through making friends began to learn new languages. Often people simply found freedom in being able to find their own voice.

Some groups visited GoMA or other Glasgow Museums' venues, and often highlighted this as one of the best aspects of the project. Glasgow Museums as a whole is working to sustain such access through

its network of Education & Access teams (another result of the *Best Value Review* and subsequent organizational restructure) as well as Glasgow City Council's Community Action Teams. We also know that some organizations we worked with, having witnessed the positive benefits of the *Sanctuary* programme, continued to develop art projects through the network of contacts created by it. In this way, we have been able to act as an agency providing a service that did not previously exist, and as a catalyst for this work to continue.

Separately, from April to September 2003, *Sanctuary: the project* presented, or was involved in, over 40 arts events across the city. These included music performances, storytelling sessions, dance and performance events, visual art exhibitions and workshops. We formed partnerships with a number of other, external arts organizations across the city, and distributed monthly leaflets and newsletters detailing all the events and project news throughout the year.

In short, over 3,000 participants from 28 countries took part in *Sanctuary: the project*, collaborating with 18 different organizations and a further 18 artists.

Through these outreach projects, *Sanctuary*:

- Provided an opportunity for asylum seekers and refugees to access an arts project and information about Glasgow Museums.
- Provided the asylum seeker and refugee community with an opportunity to have a voice in a city-centre venue through the outreach exhibitions.
- Provided opportunities for these newcomers to the city to attend events and workshops in GoMA and other venues.
- Encouraged social interaction as people attending drop-in sessions stayed longer, chatted to others and explored ways of telling their stories without language frustrations.
- Provided much needed arts projects at

drop-in centres and group meetings.
- Helped to alleviate boredom, encouraged the use of English, and provided meaningful activities for parents and their children.
- Encouraged people involved in the project to attend openings, workshops and exhibitions at GoMA, and to take pride in their work being on display.

What has the project meant for us?

The project has benefited GoMA in the following ways:

- We were able to offer opportunities and initial links for information-sharing to community groups.
- We were able to develop a reputation through the quality of projects offered and the project exhibitions, resulting in organizations contacting us for more information and to collaborate with us.
- It met a number of our aims to work with traditionally excluded groups, and highlighted the possibilities available through the arts and Glasgow Museums.
- It gave us an opportunity to provide work for a range of innovative artists, and we began to develop a database of freelancers to work with on future projects.

Another aspect of the outreach work was the two-day conference we set up for asylum seeker and refugee artists of all disciplines. They heard speakers talk about the range of arts provision, support and opportunities for artists living in Glasgow, and were able to discuss their own needs. The outcome of this conference has been the development of an independent network for asylum seeker, refugee, and existing Glasgow-based artists from across the city. Meeting regularly, the network has held exhibitions and has developed to such an extent that Glasgow City Council has appointed a dedicated visual arts officer to support *Artists in Exile, Glasgow*.

Finally, the artists and community groups

Kites at Red Road.
Photograph by Anne Elliot.

Installation shot of work by Glasgow Women's Library, *elbowroom.*
Photograph by Adele Patrick.

created a CD-ROM archive of the many facets of the programme. This was available in all Glasgow libraries as well as from GoMA. In addition, artwork produced during the project was developed into handling boxes for Glasgow Museums' Open Museum; these are available to community projects and schools across the city. Together with the artists' network, these are valuable legacies of the 15-month outreach programme. But it is the strength of the links generated between artists, communities, organizations and individuals through *Sanctuary* that will ensure that the enthusiasm and skills developed through the project are not lost, and that access to museum collections and arts resources is maintained.

Through the exhibition, events and workshop programme, *Sanctuary* had a wider target audience, attracting a range of people to each event where it:

- Encouraged new visitors by the opportunities on offer and the events happening in the gallery.
- Promoted a better understanding of the situations asylum seekers and refugees face living in this country.

Further evaluation showed that both the outreach projects and their exhibitions had raised awareness of the racial and cultural obstacles facing asylum seekers and refugees. It also looked at the impact of the project on indigenous Glaswegians and on gallery visitors. The overall programme was shortlisted for the Gulbenkian Museum of the Year award, encouraging many more people to say what *Sanctuary* had meant to them; this contributed to GoMA winning the Gulbenkian Award public vote on the 24Hour Museum website.

Sanctuary was the first of what has become a biennial series of programmes on issues of human rights identified by local and national government agendas. In line with Glasgow City Council's key objectives, this is a significant strategic development for Glasgow Museums and for GoMA. It represents a policy move that mainstreams social justice issues whilst celebrating the best in contemporary art practice. In developing the service as a vehicle for broad social change and the creation of sustainable communities, it is therefore also about collaborating and integrating resources with other sections of Culture & Sport Glasgow (previously Cultural & Leisure Services), such as Libraries, Arts Development, Community Action, Sport and Play – all of which have worked with us on subsequent programmes.

What next?

So, how has this developed into an overall vision for GoMA? Well, unlike many museums, GoMA does not maintain separate policies for acquisitions; support for artists; access for local and tourist audiences; access for excluded groups and non-visitors; programmes for schools and family events. Instead, we seek to engage and integrate these at an overall strategic level, reflecting core values of quality and equality. This means our inclusion and access work is not an add-on, but an intrinsic part of everything we do – as is our support for artists who are key to this success.

Following *Sanctuary*'s success, and the level of impact it achieved, the Council asked us to consider addressing other high-priority issues in this way. Since *Sanctuary*, we have delivered three further programmes, all with the strapline *Contemporary art and human rights*. The second programme was *Rule of Thumb*, exploring the issue of violence against women. (*Rule of Thumb* is focused on in detail later in this publication.) The third programme is *Blind Faith*, delivered in 2007, which focused on sectarianism in Glasgow and Scotland, placing it within the wider context of identity, neighbourhood and nation. In 2009 we will explore issues faced

by lesbian, gay, bisexual and transgender (LBGT) communities. We have ever-expanding ambitions for the social justice programmes, where we look to enhance self-esteem, confidence and creativity for the individual, and to promote tolerance, intercommunity respect and to challenge stereotypes at a community level.

What have we learnt?

Since 2001, GoMA's audience-centred practice has developed through these combined exhibition, outreach and education programmes. They are complex and evolving and have had a far-reaching impact on the gallery, its staff, the public, and the artists we work with. Looking back, we have learnt five key lessons.

1) It is actually the best thing that could have happened to us

The first lesson surprised and delighted us, because there is no doubt that when the issue of social inclusion is discussed in the museums and arts sector, there can be discomfort and confusion. In practice, this can lead to well-meaning but oversimplified approaches, or worst of all, a token effort. At GoMA, we certainly had concerns initially about what we were being asked to take on. In all honesty, we had our doubts about such an openly political and topical subject, but senior management recognized that GoMA was ideally placed because of the power of contemporary art to convey challenging ideas. It was agreed the work should be as ambitious as possible, so that it benefited the gallery in a positive way. We believe that the biggest danger in addressing work of a social nature is to do it in a way that suggests reluctance, non-commitment, or that you are doing it simply to tick the proverbial box.

Over the past five years, GoMA has completely turned its fortunes around through what, at the time, seemed the unlikely vehicle

of social justice issues. We are now recognized as having developed combined and far-reaching creative and innovative programmes, giving us the capacity to celebrate and present the very best of contemporary art to an increasing, and increasingly diverse, audience.

The media view is what most people experience when it comes to human rights abuses. But artists and cultural institutions have the freedom to go beyond the sound bite, digging deeper to focus on the issues of today, 'earthing' ideas and realities that can make us consider them afresh or, perhaps, crucially, even for the first time. And so despite our initial concerns, we have found we have been able to attract a number of high-profile, international artists.

Without these social justice programmes, we would not have been able to show such high calibre works to the public. On a local level, these international associations have encouraged more Glasgow-based artists to work with us. We also found we were able to attract a broader audience who, being interested or intrigued by the *subject*, found it refreshing to consider the issues *creatively*.

One artist with international prestige is Barbara Kruger, who was approached in acknowledgement of her worldwide success as an artist who places social and political issues at the forefront of her work. The subject of violence against women was what attracted Kruger to work with us. As a result, she exhibited for the first time in Scotland, utilizing the walls, floor, columns and skylight windows of the gallery and using trademark text and image works to 'speak' directly to perpetrators, victims and survivors of abuse.

The *Barbara Kruger* and *Sanctuary* exhibitions illustrate very clearly that for the first time ever we now have the capacity to attract key international artists to exhibit in Scotland. There is huge potential to introduce people to the work of these artists, in one sense because these programmes are when

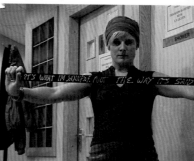

Workshop image from Base 75, *elbowroom*.
Photograph by Katie Bruce

Spine Poetry, *elbowroom*.

we have the money to do so, but critically, what attracts artists to work with us are the subjects we tackle. For us, this is a great combination, because there is no question of compromising on quality, often the first thought in some quarters when words like 'social', 'community', or 'access' are mentioned. The work stands independently, regardless of the overall programme identity, and this is essential in achieving our aims.

And we found opportunities to deliver in ways that had previously been closed to us; for example, establishing our first ever artist-in-residence programme. Initially the residency was for one month, full-time; in the next programme we expanded that to two, six-month part-time residencies, employing both an artist and a writer in association with the Library at GoMA.

The biggest discovery for us, despite our own initial scepticism, has been curatorially – to realize that we are free to curate as we choose (funding permitting), rather than being controlled by the programme as we had initially feared. There is now an overarching support and recognition amongst the team that these programmes deliver, and this has been absorbed into GoMA's core values. As one member of staff said:

'It sounds corny but you can see that it does raise awareness to the issues, seeing that we were helping people, the feedback from press, visitors' comments, the thanks from advisory board members, their feedback from the women involved – all that changed my mind…It's not just lip service, not just about being politically correct.'

These are important changes in both professional and personal attitudes, which affect the strength of programme delivery. And whilst there is clearly an emotional impact to this work, this has not meant the focus has shifted from the fine art aspect of the job.

2) Community work does not have to mean mosaics

As previously mentioned, we have found, very clearly, that we now have the capacity to attract key international artists to exhibit in Scotland.

There is sometimes a feeling in the arts world, or the museum sector, that 'community' equals something like 'mosaics' – work that has been so diluted by a 'PC' issue that it cannot be seen as a quality work in its own right. We believe we challenge this notion. And importantly, to those visitors who may come because of the subject and not for the artist's name, we are able to show what high calibre contemporary art looks like, what it can say, and what it can make you feel. Imagine someone experiencing Barbara Kruger's work for the first time, perhaps being in an installation for the first time, physically involved with the work, with this message leaping off the walls.

As well as working with high-profile artists, equally important to the quality of the programme is the engagement process between participants from our targeted groups and the contemporary visual artists who work with them to create new work. Giving participants a voice within a city-centre venue, raising awareness about issues, and providing opportunities for participants' personal self-development are all part of this.

A key example of these outreach programmes was *elbowroom*, a lead-in project for *Rule of Thumb* which won an engage Scotland award. Its aim was to encourage debate and discussion in preparation for the following yearlong programme looking at issues of violence against women. From *Sanctuary* we had learnt that to improve the quality of our engagement with participants, we really needed to extend the project time for *elbowroom* from three to eight months. Our experience with *elbowroom* informs how projects now take shape at GoMA, and continues the debate in museums

and galleries about how we can work with communities without compromising on quality or innovation.

Within a safe support structure, and with no predetermined outcomes, *elbowroom* participants collaborated with artists and developed work through workshops, events, consultations and research. Every participant contributed their experiences to the making of the work: through the conceptual and creative process, the individual voices of despair and hope, fear and recovery, rang through *elbowroom*'s unified response to violence. Rejuvenated self-confidence, self-worth and creative energy reinforced the group experience.

The work was later displayed in GoMA, and for those that shudder at the thought of putting on a community exhibition, in terms of quality *elbowroom* was described as 'a chilling but unmissable exhibition… An installation which, for all its lack of individual authorship, is as worthy of the Turner Prize as the most recent submissions of Kutlug Ataman and Jeremy Deller.'[9]

More than 45,000 people saw this small exhibition, and artists, participants, visitors and press alike recognized the strength and creativity of the work at the centre of the project. As one commentator wrote, '… while worth supporting, most community art projects are complex phenomena to interpret, their function being more therapeutic than aesthetic. But this show is an exception. It is unmissable.'[10] (For an in-depth overview of *elbowroom*, see pp.30–35.)

We are sometimes asked if our outreach work means we have given up control of exhibition development and interpretation. Well, control of how the work is presented is always negotiated – the results of collaborative projects with no predetermined outcomes can be incredibly exciting, but there is no doubt it can also be scary, although it is this dynamic which can give the work its edge. By this we

mean artists together with participants explore and investigate, and both tend to take different views and approaches to communicating their experience and knowledge – which we in the museum may not have thought of. Our experience is that this is never a limiting approach, but one that enriches both process and product.

3) Teamwork is essential

Who delivers this work? There are layers of overlapping teams, but close, integrated teamwork is essential. In delivering this kind of programme there are no false boundaries or hierarchies; what is important is that we work collectively to ensure a balanced and strategic approach, and that there is intellectual integration across all activities.

We are also reliant on, and are supported by, an advisory board for each programme. This is made up of partners from relevant organizations and Council colleagues. We have also developed a network of skilled artists with experience of collaborative work, as well as a number of other key contacts. This enables us to increase the capacity of our own, essentially small, team to deliver programmes of some considerable size across the city.

It is important to make clear that at GoMA we are experienced in the field of delivering exhibitions and participatory arts programmes, but not in the issues that these subjects involve. Therefore advisory board partnerships, and those developed through the outreach programmes, are critical to the success of exploring these issues with integrity and sensitivity. This was something not formally in place for *Sanctuary*, although we did work with many partners.

One of the key things to establish at the outset is your expertise. This is crucial for two reasons: one, it will allay staff fears that they will be expected to take on the role of a social worker; and two, because

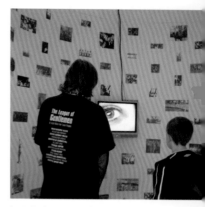

Installation shot of *Voice/ Over*, Glasgow Women's Library.
Photograph by Katie Bruce.

Member of the Makhbul Youth Group, *Sanctuary: the project*.

it recognizes your limitations and helps to identify the organizations you would like to partner. Invariably, these will come from the very communities you want to work with. It is important then, to engage with these organizations to understand and use their expertise and networks, to establish roles and manage expectations. This prevents a number of pitfalls, a major one being not to undermine their work by trying to emulate anything they do. Our role is to complement their work, and to help raise the profile of the issue. This leads to true collaboration, builds bridges with audience communities and groups, and avoids patronizing guesswork or skimming over a subject, which could do more damage than good.

The scope of these programmes means we work with a wide range of excellent freelance artists. Contact with these artists, and the variety of art forms they use, has helped to develop and broaden the skills of our Learning Assistants, which can be built on for future projects. The outreach programme also aims to work in a capacity building manner with our partner organizations, to increase their skills and knowledge as well as our own, and to enable the sharing of resources.

Of particular note is the post of Social Inclusion Co-ordinator in GoMA's core team, established as a direct result of developing the social justice programmes. The post holder facilitates communication between all the stakeholders involved, and plays a critical role in the sensitive negotiations that are often required within the heart of communities.

But this work, although challenging, has also been tremendously rewarding. Feedback from staff includes comments such as:

'The social justice programmes – that is when we function best, doing what we want to do, working together as a team, there's a tremendous effort by everyone to make it happen.'

'It's not just an educational programme about the issue – it's a massive programme that the whole museum has built in to and this is clear to visitors. Everything carries the same weight.'

'The team is close, but works even closer and is even more integrated when these programmes are running.'

4) It is emotionally demanding

These programmes are built on complex social dynamics. It is not simple, there is no ABC guide, it is not just a case of 'do this, do that'. Anyone engaging with an agenda of social inclusion or social justice must be aware of the pitfalls and understand what and who they are engaging with.

This work is dealing with real people's lives. And, for example, when funding is threatened, *then* you really realize what you are involved in. A year away from the main *Rule of Thumb* programme, funding for the central activities was suddenly in doubt. By this point we had been working with the advisory board for a year, and the lead-in project, *elbowroom*, was underway, relationships had been established, and trust generated between individuals, some of whom were the most vulnerable and excluded that we have ever worked with. We have never felt the responsibility of this work as much as we did then, and we have never forgotten it.

The artists we engage to work with us on the outreach aspects of these programmes are working and developing their practice in emotionally demanding contexts. We have put in place a high level of expertise to provide them with appropriate support. In no case was this need more evident than during *Rule of Thumb*, when artists were working with women and young people who had been subjected to violence, rape and sexual abuse. Participants were supported by staff from their own organizations, whilst artists were supported by staff from Glasgow-based

organizations such as the Women's Support Project and Wise Women.

It is important to consider the additional costs that providing this level of supervision and support entails, and our budgets for later outreach projects increased significantly from our first programme. Over and above actual contact time with participants, artists need to commit considerable time to research, meetings, supervision and the communication process.

As well as gallery visitors and outreach project participants, we also target community groups so that those with particular experience of the issues can access the exhibition and workshops in ways tailored specifically to their needs. By doing this, we reach another layer of new and diverse groups and are able to introduce them to GoMA and our work. But there is a great responsibility here also. It is essential to have contact with visiting groups beforehand to explain the content – that it may be upsetting, what will happen, what will be discussed, the kind of artwork involved, and critically, that support workers will also attend.

Similarly, with schools we ask teachers to visit first to decide if it would be appropriate for their class. Colleagues in the Museums Education Service support us in writing our own teacher's packs, in terms of notes, resources, websites, and ideas about what to discuss in the classroom.

Emotional support is essential for our own staff, particularly those in frontline delivery, such as our Learning Assistants. Participants' responses can be unpredictable, so staff need to be prepared for this, to enable them to focus on their delivery, knowing that they have

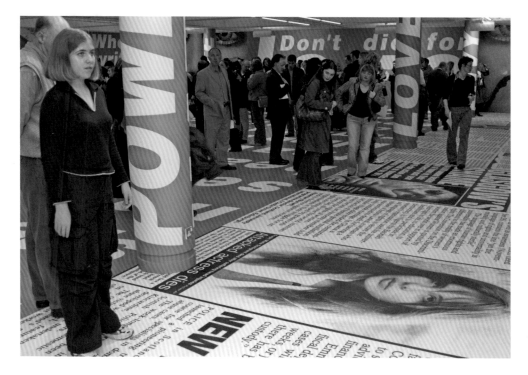

The opening night of the *Barbara Kruger* exhibition.

19

support before, during and after each session.

Specific training and briefings are provided for every member of staff in the building, no matter what their responsibilities. This not only ensures that we all share an understanding of why these issues are the focus of large-scale programmes of work, but also helps equip us for visitors' reactions. For example, during *Sanctuary* – which evoked very strong personal reflections and contemplation – hardly anyone wanted to engage with our Visitor Assistants in the exhibition space. It was our Retail staff who found themselves unexpectedly at the receiving end of the many different kinds of emotions which visitors had begun to process by the time they made their way to the shop.

5) Do your homework: understand the preparation time required

I have touched on some of the complexities of undertaking social justice programmes. And in considering and understanding what you take on when genuinely engaging with contemporary issues, these complexities clearly show that a great deal of preparation time is required.

Understanding and empathizing with participants on projects is not quick, and this process has evolved as the programmes have progressed. Time is needed to build a relationship of trust between the gallery, artist, participants and community organizations; to research the issues involved; research potential artists; develop lead-in projects; for the recruitment of artists and teacher placements; for meetings with staff, the advisory board and colleagues across the wider networks; building and supporting relationships with all those involved; training for everyone. (Not to mention the time-consuming nature of funding applications.) And, importantly, time has to be built in to allow for genuine flexibility in terms of the possible and unknown outcomes of the outreach programmes, so that we can respond directly to the needs of participants rather than shoehorn them into a fixed agenda.

Evaluation and sustainability

What about these other critical issues that we all have to be concerned with? It can be difficult to evaluate every aspect of this kind of work in ways that we might normally expect. Vulnerable participants are often in crisis situations, and transient groups can make it difficult to track the impact of our work. However, we document and evaluate everything that we can, usually encompassing:

- focus groups and interviews with artists, participants and the wider art community;
- focus groups and interviews with museum staff;
- interviews with members of the advisory board;
- visitor surveys during the central exhibition;
- analysis of exhibition comments books and press coverage of all aspects of the programme.

For *Rule of Thumb* we also commissioned an independent evaluation. We wanted an objective analysis in terms of whether stakeholders' expectations had been met; to ascertain whether we were using the right model for these programmes; and to assess the impact on our audiences and our profile, amongst other criteria.[12] The executive summary points were:

- *Rule of Thumb* exceeded expectations in using contemporary art to explore social justice issues. The perceived impact of the programme exceeded the expectations of both stakeholders and the advisory group. Stakeholders across Glasgow City Council held the programme in high esteem, and were impressed it had added weight to the ongoing corporate policy work around violence against women. Consultees believed that the programme delivered an increased public awareness of the issue. Advisory

group members were impressed by the quality of product, and by media interest in the subject.

- *Rule of Thumb* engaged and attracted a wider public to the Gallery of Modern Art.
 It was found that the nature of these programmes can simultaneously help build audiences and promote awareness of contemporary issues. From visitor surveys, and details of participants in both the workshop and outreach programmes, it was clear that new audiences had been attracted to GoMA because of the *Rule of Thumb* programme. This included local residents and tourists, some of whom cited the programme as a reason for choosing Glasgow as their preferred city-break destination.

- *Rule of Thumb* worked effectively with local partners.
 Local partners – largely from the voluntary sector and all dealing with diverse and often challenging client groups – were very positive about the programme and their engagement with it. Many were honest in acknowledging that they were initially sceptical about the approach, but had been impressed by the sensitivity of Gallery staff and the artists, and had found the interventions extremely productive. In all cases, expectations had been effectively managed on all sides, and many local projects had sought to develop a continuing arts-based programme. Issues of sustainability had been actively considered from the outset, and the Gallery had helped direct local partners to continuing Council and other services.

- Significant effort was made to reach the hardest to reach.
 The impact on participants has been varied and significant, and we actively targeted many of the hardest to reach. They reported a range of positive impacts – therapeutic, the development of soft skills such as listening, and being introduced to learning.

- *Rule of Thumb* has contributed to the re-defining of the Gallery of Modern Art.
 Respondents reported that both GoMA's commitment to Scottish contemporary art and its programme of work relating to social justice issues makes it 'unique'. When asked to identify benchmarks for the Gallery, respondents said that appropriate comparators were international. Artists, particularly, were encouraged by the Gallery's direction and its clear sense of purpose and positioning within the city.

This is the power of contemporary art. Artists have an extraordinary capacity to communicate realities we may have become immune to through other media forms. It is for this work that GoMA is being increasingly recognized both at home and abroad: for the quality and extent of its work in using contemporary art and artists to explore a number of subjects of current concern.

But we could not deliver the quality of work required for these subjects to be considered or *re*considered seriously, with integrity and sensitivity, if it were not for the artists of distinction that we work with. Whether they are an artist of international profile, or one whose expertise lies in the collaborative nature of their practice when working with local communities, at all times we are concerned with quality. We place value on giving artists the freedom to pursue their interests and new work within the continuing narrative of their practice.

A prime example of this is *Blind Faith*'s central exhibition, *Histrionics*, described as: '[Roderick] Buchanan's strongest work to date. A brave and powerful social lament, evoking countless unrecorded episodes of physical pain and mental torment, it is surely one of the most significant Scottish achievements of the past few decades.'[12] Gutsy and bold, *Histrionics* is an open and personal presentation of issues that Buchanan has long been thinking about as a Glaswegian, and as an artist who has been

Written Sheets at Red Road.
Photograph by Anne Elliot.

concerned with identity politics from the very start of his practice.

Blind Faith has received recognition from Scotland's First Minister, as well as an award from Sense Over Sectarianism. At the time of writing, as we continue to deliver the *Blind Faith* programme, we are already involved in planning 2009's *Contemporary art and human rights* LGBT focus. We hope to amplify our ambition still further within this programme, developing our range of partners, continuing to expand the programme's visibility across the city, the UK and abroad, increasing the opportunities we offer to artists as well as the scope of our consultative practice.

Although it is impossible to detail every aspect of this work, I have tried to convey the level of undertaking behind our social justice programmes and how we have fused the underpinning issues we take on with the best in contemporary art. And in so doing, we have created a model in practice, where these two very strong ambitions work together in a complementary way.

The title of this chapter is 'Giving Elbow Room'. The term 'elbowroom' was put forward by one of the outreach groups for *Rule of Thumb* when they were looking for a name for their own exhibition. They had begun to develop their artwork based on play, and having the space to play and do things, simple things that they would not normally have been able to do. In preparing this chapter, it became apparent to me that this is an appropriate overall term for this work of ours: in its literal meaning, elbow room is having sufficient scope to move or function; the ability to make choices; scope for freedom of action or thought. If you do not have enough elbow room, you do not have enough space. It is easy then, to see how poignant this title is. An audience-centred, engaged approach to the work of museums and galleries can be a powerful tool in Giving Elbow Room.

1 *Best Value Review Final Report, Museums, Heritage and Visual Arts*, July 2001, p.55, Glasgow: Glasgow City Council.

2 Bailie Elizabeth Cameron, p.v, *Sanctuary*, 2003, Glasgow: Glasgow City Council.

3 Sally Daghlian, p.viii, *Sanctuary*, 2003, Glasgow: Glasgow Museums.

4 Holt, A, 2002, *Naked Spaces Location 3: High Riser*, Glasgow: Glasgow Museums.

5 Ibid.

6 Ibid.

7 Iain Gale, Art that will set you free, *Scotland on Sunday*, 13 April, 2003.

8 *Sanctuary: The Exhibition* Visitor Survey Summary Report. Prepared for the Gallery of Modern Art by Hannah Brocklehurst and Maxine Martin, Department of Museum Studies, University of Leicester, 2003.

9 Iain Gale, *Scotland on Sunday*, 16 January, 2005.

10 Ibid.

11 Evaluation of *Rule of Thumb*, carried out by Paul Zealey Associates for the Gallery of Modern Art, 2007.

12 Iain Gale, *Scotland on Sunday*, 15 April, 2007.

Rule of Thumb: Contemporary art and human rights

'Violence against women kills or incapacitates more women aged 15–40 worldwide than cancer, malaria, accidents and war combined.'

(Heise, 1994)[1]

'… action to eliminate violence against women is the responsibility of all of us: the United Nations family, member states, civil society and individual women and men.'

Kofi Annan, Secretary-General of the United Nations, 25 November 2000

During 2003/04 Strathclyde Police recorded 8,112 domestic abuse incidents in Glasgow. Figures show that 9 out of 10 incidents were men abusing women.

As these statistics indicate, violence against women is a major human rights concern. Glasgow City Council is committed to supporting women and children who experience male violence, and is involved in a number of initiatives. As detailed in the previous chapter, GoMA was asked to find a voice for this often silent issue through the impact and visibility of contemporary art.

The result was *Rule of Thumb: Contemporary art and human rights*, a programme with four key areas:

- *elbowroom* – a lead-in exhibition and outreach project (2004/05)
- outreach projects and resulting exhibitions (2005/06)
- major exhibitions by Barbara Kruger (2005) at GoMA and Tramway
- an education and events programme including an artist residency (2005)

Our aim was to work with a range of organizations to present exhibitions and projects raising awareness of the issues generally, while also targeting specific audiences. Essential to this was a programme of quality and of high artistic impact. All aspects of the programme were free, funded by Glasgow City Council with additional funding support from the Scottish Executive (for *Rule of Thumb*), the Scottish Arts Council (*elbowroom*), the Scottish Museums Council (for the *Rule of Thumb* participatory outreach programme) and North and South Lanarkshire Councils (for the Calendar Project).

In early 2003 the core project team at GoMA was established. It consisted of Victoria Hollows, Museum Manager; Ben Harman, Curator, Contemporary Art; Katie Bruce, Social Inclusion Co-ordinator; and Alicia Watson, Education & Access Curator. We developed a draft programme based on the success of *Sanctuary* (2003), which included a lead-in collaborative show, a major exhibition with an international profile, an outreach programme and exhibition, and a programme of education and events. In July 2003, we sent out invitations to a number of key people in statutory and voluntary agencies in Glasgow asking

them to support us on the project. Our main partners were Amnesty International and Rape Crisis Scotland.

To provide further support, we established an advisory board of representatives from our partner organizations, Council colleagues, and several Glasgow-based women's groups and organizations. This was intrinsic to the development of the *Rule of Thumb* programme, and the board was instrumental in contacting and recruiting groups for *elbowroom* and the main outreach programme. Representatives from Glasgow Museums Communications Section and the Press Office were also included on the advisory board so that we could develop appropriate marketing, PR and design for such a sensitive issue.

We wanted to give the programme a title which covered all the issues raised, was not necessarily negative (we wanted to convey the fact that although statistics are horrific, many women survive), which explored the mixture of myth and fact when talking about violence against women, and which would not dissuade men from visiting the exhibition. *Rule of Thumb* was suggested because it has been said that in the eighteenth century, a husband would not be charged with violence against his wife as long as the stick he beat her with was no thicker than the width of his thumb. This 'rule' has been disputed as there is no concrete evidence for it; the phrase is more often associated with joiners using a thumb

width as measurement, so the title embodied both myth and fact.

The overall *Rule of Thumb* programme was launched in December 2004 with the opening of *elbowroom*. This lead-in exhibition was the culmination of an eight-month outreach project with four groups based in Glasgow (see pp.30–52). The rest of 2005's programme included major exhibitions of Barbara Kruger's work, held at GoMA and Tramway, as well as a public artwork billboard installation in Glasgow Central railway station (pictured p.103). Nine further outreach projects with artists of all disciplines took place across Glasgow, and we ran a range of education events and workshops at GoMA. For the first time, we were able to host an artist-in-residence as part of the programme.

The *Rule of Thumb* programme employed 24 freelance artists across the education and outreach programmes, and had over 1,250 participants. Over 335,000 people visited the exhibitions at GoMA, while Tramway welcomed 3,057 visitors to *Twelve* in the short time it was open. We were also able to part-fund other projects with partner arts organizations across Glasgow (see pp.90–98).

An extensive marketing campaign covered all aspects of the programme. We produced a general leaflet detailing the overall programme, two events leaflets to cover the six-month Gallery-based education and events programme, a

Artwork for *DOMESTICA* by 218 at the Necropolis, Glasgow.
Photograph by Anne Elliot.

poster campaign for the Barbara Kruger exhibitions, placed adverts in key art magazines and achieved extensive coverage in the general press. GoMA's *Barbara Kruger* exhibition was also described as a highlight of the first Glasgow International (Gi) visual arts festival in 2005. The GoMA Retail team sold exhibition merchandise in the shop, with a percentage of proceeds going to programme partners Rape Crisis Scotland and Amnesty International.

Benefits for GoMA

The main benefits for us, and for the Museums Service as a whole, were:

- We worked with new partners and artists who enriched the quality of the programme we offer, including Barbara Kruger, winner of the Golden Lion at the Venice Biennale 2005. She was an enthusiastic supporter of the programme, and exhibited in Scotland for the first time.

- We worked with new, non-gallery, audiences, gaining their support and confidence and creating opportunities for GoMA staff and freelance artists to develop their practice and new artwork for the gallery. It was a learning experience to see what potential GoMA has as a social space.

- Visitors to the Gallery raised a powerful debate, documented in the comments books from the exhibition and workshops.

- The profile of GoMA's work, and of the organizations that worked with us, was raised.

- We received a huge amount of positive press coverage and feedback.

- The increased recognition of the niche that GoMA is developing through its social justice programmes while supporting artists' practice was coupled with an increase in enquiries about our work.

- It raised questions about how we work and what we can develop for future programmes.

Legacy

What were the outcomes from *Rule of Thumb*? To summarize:

- We received an engage Scotland Visual Art Education Award 2005 for the *elbowroom* project.

- We have ongoing partnerships with other organizations, artists and local authorities.

- Throughout 2006, the website calendar from the Calendar Project was online at www.lw365days.org

- Participating groups have gone on to source other arts-based projects.

- Work has been installed in the community venues where they were originally created.

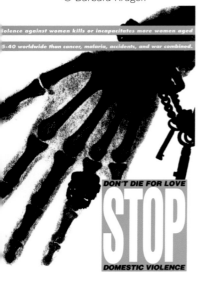

Poster artwork designed by Barbara Kruger for the Gallery of Modern Art, Glasgow, 2005.
© Barbara Kruger.

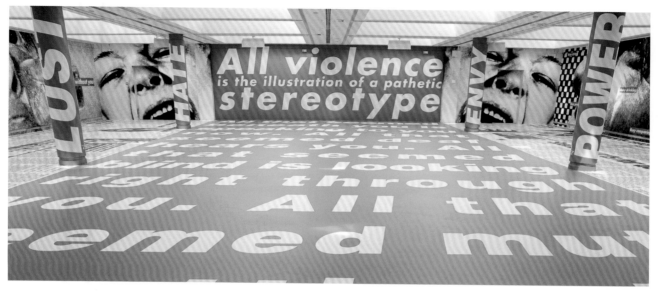

- Visitor figures at GoMA continue to grow as we develop an increasingly diverse audience.

- Beyond the immediate GoMA audience, we gained greater recognition internationally. This has led to a host of enquiries from organizations and individuals wanting to use material from the *Barbara Kruger* exhibition for their own awareness-raising campaigns and other purposes. These include Amnesty International, Finland and Slovakia; Walla Walla Community Centre, Australia; the University of Geneva, Switzerland; the World Health Organization; and Slovakian press. More locally, Edinburgh City Council (Community Safety Unit) has used the artwork made for Glasgow on publicity to raise awareness of violence against women.

Evaluation and sustainability

The *Rule of Thumb* programme attracted great interest, and visitors' comments have been startlingly profound, expressing a range of powerful views. An ongoing evaluation process informs how future programmes take shape at GoMA, continuing the debate about how museums and galleries work with social justice issues and communities without compromising on quality or innovation. Visitors, and the non-arts organizations we worked with, have experienced and overwhelmingly appreciated the extraordinary impact a gallery can have, not only in communicating ideas and messages in ways that encourage people to think about something in a new light – or for the very first time – but also in boldly expanding its activities through innovative partnerships, networks and creative processes.

The *Barbara Kruger* exhibition.

Comments from visitors

Response Space in the *Barbara Kruger* exhibition.

'My heart is pounding, my hands are shaking, my stomach hurts and the tears have fallen and continue to well and overflow as I look and read! Thank you Barbara for bringing these issues to the audience, if even in some way it provokes thought/change, you are truly an artist.'

'HARD – VERY HARD TO SEE AND TAKE IN – THANKS for creating it. I saw a lot of school children here today – I hope it makes a difference in their life.'

'I came to this exhibit when it was first displayed and for months I return to see it, as at the moment, there hasn't been any artist that has captured the vulnerability of being victimized in a relationship. This has not disappointed.'

'An important, provocative piece. It made me want to cry and scream at the same time. It's time to stop accepting violence. It's time for women and men to speak up for those who cannot or will not speak for themselves.'

'Just stepped in without any idea of what we were coming to see – made three strangers stop in their tracks… all had the same gut reaction of "Wow!" with a kind of sadness at the reality but sense of celebration at what this art is trying to achieve.'

'One of the most positive forms of political art that is not only pro-active, educational and interesting but, most potently and importantly, visually stunning in this political climate of intimidation and fear.'

'Very powerful. I didn't expect that. I'm glad the sex-trade has been included as abuse against women. I wish the whole city would see this.'

'I burst into tears seeing this. Wonderful wonderful! Well done – thank God we can have such an exhibition so visually noisy to illustrate these issues.'

'I have rarely seen anything so powerful. The comments of others are equally powerful.'

1 L Heise, A Germain and J Pitanguy, 1994. *Violence Against Women: The hidden health burden*, World Bank Discussion Paper 255. Washington DC: World Bank.

1

elbowroom

lead-in exhibition
and outreach projects

An overview

Duration

Project
February–December 2004

Exhibition
9 December 2004–
14 February 2005

Artists

Core artists
Katie Bruce, Anne Elliot,
Rachel Mimiec and Janice
Sharp

**Artists brought in to
develop aspects of the
work**
Karen Vaughan, James
Mclardy, Belinda Guidi,
Cassandra McGrogan,
Nicky McKean, Naheed
Cruickshank and
Lesley Craigie

Opposite: Entrance to the
exhibition.
Photograph by Ruth Clark.

30

'A chilling but unmissable exhibition … An installation which, for all its lack of individual authorship, is as worthy of the Turner Prize as the most recent submissions of Kutlug Ataman and Jeremy Deller.'

Iain Gale, *Scotland on Sunday*, 16 January 2005

The groups

Base 75, Glasgow Women's Aid, Glasgow Women's Library and Red Road Women's Centre. These groups work in the field of violence against women, and for *elbowroom* we worked with the women and young people who use their services.

Background to the project

We have always approached the social justice programmes as an integral part of the overall GoMA programme. Building partnerships with organizations in the field commits us to running these programmes with integrity and sensitivity, always considering the needs of participants and our partners. Part of this commitment is a dedicated temporary exhibition in Gallery 3 at GoMA showing work on the same issues in the year preceding the main programme.[1] This raises public awareness of the programme and introduces the work we do.

For *Sanctuary*, artist Patricia McKinnon Day had worked in Sighthill in Glasgow, and then developed her own work based on her experiences. For *Rule of Thumb*

we wanted to raise the profile of the collaborative outreach work between artists and communities and to use the opportunity of a Gallery 3 show to give more focus to that work. We also wanted to use *elbowroom* as a pilot project so we could develop the projects for *Rule of Thumb* in 2005.

GoMA works with other agencies in Glasgow City Council to plan the annual UN 16 Days of Action for the Elimination of Violence Against Women. This is an international programme to raise awareness, encourage debate and generate discussion on violence against women and violation of women's human rights. To coincide with the 2004 campaign, we opened *elbowroom* on 9 December.

Funding

During 2003 Katie Bruce secured core funding from Glasgow City Council and further funding from the Scottish Arts Council Lottery Fund for Access and Participation. When it became clear that the *Labyrinth of Life* event (see p.50) would require more funding, the Red Road Women's Centre raised further money from the North Glasgow Healthy Living Community.

Recruitment of groups

We approached the groups involved in *elbowroom* through contacts from the *Rule of Thumb* advisory board. These were groups that worked with women affected by the issue in its broadest

elbowroom

9 December 2004 – 14 February 2005

Base 75
Glasgow Women's Aid
Glasgow Women's Library
Red Road Women's Centre

elbowroom is supported with funding from:

elbowroom information

organizations

available in large print from the front desk

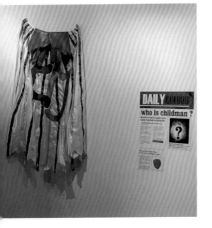

Installation shot of *Childman* by Glasgow Women's Aid.

sense: prostitution, young people affected when their mothers had had to leave home, women directly affected and those involved in campaigning and research. They were all groups that were not using the Museums Service and that were considered 'more difficult to engage' with because of their vulnerability and isolation. Katie Bruce made the initial contact, approaching the groups with a project outline.

Selecting the artists

We selected the artists on the basis of their extensive experience in collaborating with community groups and individuals. Anne Elliot has been involved in collaborative art projects in Scotland and abroad, primarily in a hospital setting – using the hospital as a community – and also on housing schemes and with voluntary organizations. She has also published on collaborative practice and the processes involved.[2] Rachel Mimiec had exhibited at GoMA previously, and the curators knew the quality of her work. She had also worked with Anne Elliot on Fusion[3] and has a very good reputation for her collaborative work with communities. Katie Bruce and Janice Sharp worked for GoMA, and were involved in the project to develop staff skills as well as being practising artists interested in collaborative projects. The opportunity to work with Anne and Rachel to develop staff's knowledge and skills was also a priority.

Structure

The project

Katie Bruce developed the structure for *elbowroom* with the four organizations involved and the artists. *elbowroom* was set up so that two artists worked with each group on their project. These two artists developed 26 workshops, which took place in the group's own community venues or at GoMA. The first workshops were often more like taster sessions, allowing participants to gain more confidence in using art materials and discussing ideas. As the project progressed, regular sessions were run in the organizations' venues and visits to exhibitions and talks were arranged. Further discussions and research with participants led to meetings with other organizations (including Wise Women and housing associations), which fed into the whole art-making process. Artists and participants were then able to collaborate and develop a range of new work in the workshops and at arranged meetings. Other freelance artists were brought in at the final stages of the project to design and edit work, such as the fanzine and films.

Providing support for both the participants and the artists was important to this project because they were exploring a number of sensitive issues. Ensuring that the organizations we work with provide staff to support participants (so that the artists do not

become therapists) is a key part of our project planning. The artists themselves have access to training by a professional in the field before a project begins, and this support continues as the project progresses. (For *elbowroom* we had Janette De Haan from the Women's Support Project.)

From the beginning, the artists decided to work as a team rather than each taking a separate project. Before workshops began they met with all the groups involved to find out what each project would entail. The potential of the groups' collaborations and where the artists' skills and experience would produce the best relationship were discussed and the projects were then allocated. Artists continued to meet as a team to discuss work and to bounce ideas around – this proved very useful for the development of the artwork.

The exhibition

The four core artists worked on the installation of the exhibition with GoMA technician Brian Dargo. They consulted the groups about where their work would be placed in the exhibition, and some groups worked in the space itself to finalize their artwork. The private view of the exhibition was opened by Glasgow City Councillor Irene Graham, and the exhibition ran for 10 weeks. Once the work was de-installed, we returned it to the groups, along with copies of any films that had been made.

The marketing

The marketing for the show was just as important as the show itself. One of the intentions of the exhibition was to empower the women and young people involved in the project and to give them a voice in a major city-centre venue to highlight the issues. They were keen that there should be free information for visitors to take away. This was vital to encourage debate and to provide details of organizations that can help those affected by abuse. Glasgow Museums' marketing and design teams worked very hard to create a branding for the show; it had to not alienate men, but had to include information about the project and organizations for women – and men – to contact.

Installation pieces, Glasgow Women's Library. Photograph by Ruth Clark.

Women@play installation.
Photograph by Rachel
Mimiec.

What was achieved

What worked

The participants' commitment to the project and the power of the exhibition surpassed our expectations. Everybody (artists, participants and staff) contributed to the making of the work, with some participants drawing on their experience of violence. With *elbowroom* we had intended to set up a dialogue between participants and the artist to engage them in the process of developing high quality new work for exhibition in one of GoMA's main spaces. In the end, it involved over 150 women and young people making art, over 300 people came to the private view, and over 45,000 visitors saw the exhibition. The strength and creativity of the work was core to the project, recognized not only by the artists and participants, but also by visitors, press, other art organizations (an engage award) and the Scottish Executive.

What we learned about how participants used the projects

elbowroom engaged women and young people who often had low self-esteem and who felt isolated because of their current situation. Some of them also felt that they were perceived as weak for putting themselves in a violent/ abusive situation, or to blame for what had happened. From the interviews we carried out as part of the project evaluation, it emerged that participants had used the project in different ways:

- some used the artists and the work they produced for support and to help them through a vulnerable time;
- some used the project to highlight issues affecting them and to change the perceptions of 'woman as victim' and of women involved in prostitution;
- some used the project because they were interested in the issue, and in having an opportunity to work with artists.

What was difficult about the project

The programme structure and timetable were very tight, and this put constraints on some decisions we had to make. Also, the amount of work the projects generated and the support the artists needed to realize the artworks was greater than we had expected. We all felt that the set up of the project was right, as the artists worked better when there were two of them on each project, but then we had to factor in extra time in order to make sure we communicated the ideas, planning and structures for developing each project. We had not factored this in to the fees available for the freelance artists, but we refined this for the *Rule of Thumb* outreach projects.

Comments and feedback

'I found that it helped my self-esteem and confidence and I found out also that I have an interest in art.'

Participant, Red Road Women's Centre

'I popped into GoMA on Thursday night to have one last wee look and ended up shedding a few tears. That visitors' book should perhaps be an exhibit in itself! I was really surprised at how busy the gallery was – I'd been expecting a tranquil empty space (it reminded me of the first time I visited my grandmother's grave on a Christmas Day – I'd envisaged solitude but was confronted by the proverbial Sauchiehall-Street-on-a-Saturday-afternoon). Anyway, it was really great to see so many people there.'

Co-ordinator, Base 75

'Overall it was a good thing, and the fact that it was recognized by others and the press showed that it was strong work. People reviewed it as a contemporary art show. It gave the women and young people voices and those voices might have been heard…The wider ramifications of this are probably invisible, and if it has touched one person then that is great.'

Artist

'…while worth supporting, most community art projects are complex phenomena to interpret, their function being more therapeutic than aesthetic. But this show is an exception. It is unmissable.'

Iain Gale, *Scotland On Sunday*, 16 January 2005

'An exhibition that has truth, honesty and value at the heart of it. I wish more exhibitions were like this.'

Visitor comment

'*elbowroom* explored issues surrounding women and violence with such eloquence that one rather hopes that the women involved (mostly anonymous) continue to work together as artists.'

Jack Mottram, *The List*, 20 January 2005

Awards

engage Scotland Visual Arts Education Awards 2005

Installation shot of *Shed*, Glasgow Women's Aid. Photograph by Ruth Clark.

1. Gallery 3 is a small temporary gallery at GoMA where we show four exhibitions a year.
2. *My Father is the Wiseman of the Village: Explorations in collaborative practice*, 2002, Edinburgh: Artlink and The Fruitmarket Gallery.
Extraordinary Everyday Explorations in collaborative art in healthcare, 2005, Edinburgh: Artlink, Edinburgh and the Lothians.
3. *Fusion* was a two-year programme of collaborative artwork with patients and departments in the hospitals of Edinburgh and the Lothians.

Base 75

Duration

Project
February–December 2004

Exhibition
9 December 2004–
14 February 2005

Artists

Core artists
Anne Elliot and Katie Bruce

Video edit
Cassandra McGrogan

Opposite: CCTV footage of
workshop.
Photograph by Katie Bruce.

The group

Base 75 is for women involved in prostitution. It is located in the centre of Glasgow, near where the women work, and offers them a place to come for medical services, condoms, housing, counselling, advice, support and a nightly drop-in session when they can chat, change and get something to eat. The project involved both the women using the service and the women staffing it. This meant the artists worked with women in their twenties and older, whose experiences of violence and abuse could be quite shocking at times, but who were all survivors of their situations.

Process
Why we approached Base 75

We were working with organizations who support women subjected to domestic abuse, but working with women from Base 75 gave us the opportunity to challenge the perception that violence against women is only domestic violence. Indeed, prostitution itself can be seen as a form of subjugation of women. In addition to experiencing violence on the street, the women often experience it at home at the hands of an abusive partner or parent. Coupled with issues such as substance abuse and homelessness, this often leads to them feeling incredibly isolated and vulnerable, often worsening their situation.

The project

The initial response from staff at Base 75 was fairly guarded. They had been involved with a TV journalist previously, whom they felt had exploited the women for their own agenda. Knowing this, we held development meetings before the group started to establish the artists' role and to make sure the women were involved in the decisions and process. The artists also met with staff on an ongoing basis to ensure that the work they were doing was appropriate.

This project differed from the other *elbowroom* projects as there were no established groups for the artists to join. There was a drop-in session at the base every evening, but this was an important time for the women to get information and advice on other matters such as housing and safety. We also thought it might be too chaotic, as women often used this time to eat and get ready before going out to work. The main opportunity to set up a regular group where the artists could contact the women was a cooking group. Base 75 supplied different cooking ingredients each week and women were encouraged to cook the food and stay for dinner. It was an interesting group for us to begin with, as research in Base 75 had shown that for many of the women, the sandwiches provided at the drop-in were often the only proper meal they ate.

So the two artists joined this session, initially to introduce themselves and the

Still from *No Apologies*.
Photograph by Anne Elliiot.

Photograph of the installation
in Base 75.

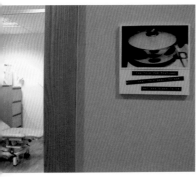

project to the women, and to encourage them to use the cameras and drawing materials that we made available. However, even these workshops proved to be quite hectic, and there was not much time to pursue creative ideas. The chaotic nature of the women's lives (as a result of drugs, homelessness, etc.) meant that the artists could not rely on regular attendees, and had to work with a low attendance rate – this was common to any group that had been run in the base.

Some ideas had been generated through conversations with the women, so we began to put posters up weekly to advertise what was going on. On the poster we put an image of what the group had done the week before, and information about what they planned to do next. This helped to attract more women, and at least two or three of the women became regular attendees.

The ideas for artworks at Base 75 were generated from discussions over dinner with the women who use the centre and with the staff who support them. Violence, housing, self-defence, drugs, policing and dress codes were all discussed, and this led to the creation of artworks including a juke box of songs on violence against women and flower portraits.

The artworks in *elbowroom*, *no apologies*, *Leaflets* and *If My Voice Was Proper They'd Listen* were simple responses to conversations that arose over the weeks.

Work

No apologies
This video work was a response to discussions about self-defence. The women were filmed yelling the word 'No', the first and most powerful weapon of self-defence. Their voices are loud and powerful, then immediately muted. The timing of the 'Nos' is random, surprising the viewer and giving them the opportunity to fully understand what it means. It sets up a contrast between finding your voice and suffering in silence.

Leaflets
Self-defence, violence, housing, drugs, policing, and clothes were all discussed, and these leaflets documented the group's responses to their conversations. The only way the voices of the women who use Base 75 are heard is through the 'Beware Notices' book, where they can leave messages warning of potentially violent clients. *Leaflets* gave these women a public voice and a way of passing on their information and experience.

If My Voice Was Proper They'd Listen
The top shown in *elbowroom* was quite stereotypical of what society might think a woman involved in prostitution would wear – it was glittery, bold, revealing. But based on what we heard in Base 75, the women wear anything to work, including joggers and football tops. The work explored the myths; no matter what

message the clothes might appear to give, it is the person that is of value, and they should be listened to and respected.

What worked

The work in the exhibition was incredibly powerful, and the staff felt that it was very worthwhile. Women who were not involved in the project itself had also visited the exhibition, and those who had participated fed back that they enjoyed it.

What was a surprise

The slideshow of the artworks relating to the theme was one of the best workshops in terms of generating conversation and getting responses – the women talked a lot about it. The base manager had originally suggested that the artists didn't do this workshop – she did not think it would work as the women would not be interested in talking about the artworks. Actually, it proved to be one of the best discussions the group had about art and the issue of violence against women.

What didn't work

We struggled with numbers for the workshops, but given the hours we had available to work with the women, we managed to achieve a lot. The project was very positively received by those involved as well as those who were not able to make the workshops but visited the exhibition. A longer project would have supported a more flexible way of working, and we could have reached more women.

Comments

'For the women and staff involved it was an opportunity to be heard: an opportunity to challenge apparently commonly held public perceptions regarding prostitution and other forms of gender-based violence. Involvement in this project also made "art" more accessible to the women involved.'
 Co-ordinator, Base 75

'The leaflets are beautiful. The silent screams gave me shivers. You have done very well. Thank you for celebrating what is strong and positive and seeing what is sad and under the surface.'
 Visitor comment

'Inspirational, creative and highly fulfilling project which ground-breakingly gave a voice to the most excluded citizens in Glasgow (women involved in prostitution).'
 Worker, Base 75

Installing strawberries in the garden outside Base 75. Photograph by Anne Elliot.

Glasgow Women's Aid

As if I am someone, jewellery
piece.
Photograph by Katie Bruce.

The group

Glasgow Women's Aid (GWA) offers support, information and temporary accommodation for women (and their children) who are being or have been, physically, emotionally or sexually abused by their partner or ex-partner. Following research into the effects that living with domestic abuse has on children, GWA have also added children's workers to the support they offer.

Process

Why we approached Glasgow Women's Aid

Staff from Glasgow Women's Aid were on the advisory board for *Rule of Thumb*, and had expressed a keen interest in being involved in the outreach projects. As the provision of children's workers for young people was quite a new service, they wanted to explore the range of projects they could offer. *elbowroom* worked with young people in refuge aged between 11 and 16 and with the GWA children's workers to explore the issue of domestic violence.

The project

We had a number of meetings with GWA's children's workers before the project began. Because the young people involved were still in refuge, we knew that care would be needed in approaching the subject of domestic violence. After discussion with the children's workers, we decided to begin the project without mentioning the exhibition or the theme. Fourteen children attended the first workshop at GoMA, and this was more a taster session in art-making and a chance to meet each other.

We had similarly large numbers at the next few workshops, and we experimented with different techniques to encourage confidence in the young people and to develop a relationship with them. We hoped this would lead to the creation of work for the exhibition. Following on from a discussion about personal space, the young people began to create their own temporary walled space in the Studio at GoMA, adding to it on a weekly basis. This was a breakthrough, as they began to claim the space as their own, no longer asking what they should do next but making their decisions as a group.

Because of families moving out of refuge, changes in school timetables and other commitments, numbers did drop near the summer holidays. But by this point we had explored various ideas, using the United Nations *Rights of the*

Child document[1] as a starting point. This included working on large posters to illustrate their rights as young people. After each session there was a discussion about where the work could go next, and this led to the development of ideas for three key elements, later included in the exhibition:

- an art day in the park to build a place (which became known as the Shed) for young people;
- making posters and deciding where they could be sent – one of these posters was exhibited in the final exhibition;
- a superhero – Childman.

The installation of work in the exhibition involved both the staff and the young people, and was decided at a workshop in the gallery space. Final decisions were made with the young people taking responsibility for how the Shed would be displayed.

Throughout the project the artist met regularly with staff. The young people had a lot going on in their personal lives, and the support of staff to help them to focus in order to develop the work was vital. The staff talked about where they could develop the project and how they could support the young people's ideas beyond the workshops. This helped the project partnership, and ensured that everyone involved was aware of any issues that arose. The support and commitment of the staff were key, and although it meant a lot of extra work, they felt that the end results for the young people and their mothers justified the time involved.

Work

Shed

A smaller group attended the first art day in the park. We looked at various ideas that the young people had about messages, safety and their rights. The core group continued with workshops at GoMA until the end of the 26-week project, when they decided that their work would develop with another day in the

Installation of *Shed* in Tollcross Park. Photograph by Katie Bruce.

park. Following on from their creation of the room in the Studio, they decided to build a safe place in the park that would hold and give information to young people. This translated into building a basic shed to be covered by their artwork. James Mclardy built the frame, and with his help Katie and the young people installed and finished the shed at Tollcross Park on 20 October 2004. This was documented and filmed, and at the end of the day the shed was dismantled and kept to be installed in the exhibition.

Inside *Shed*.
Photograph by Katie Bruce.

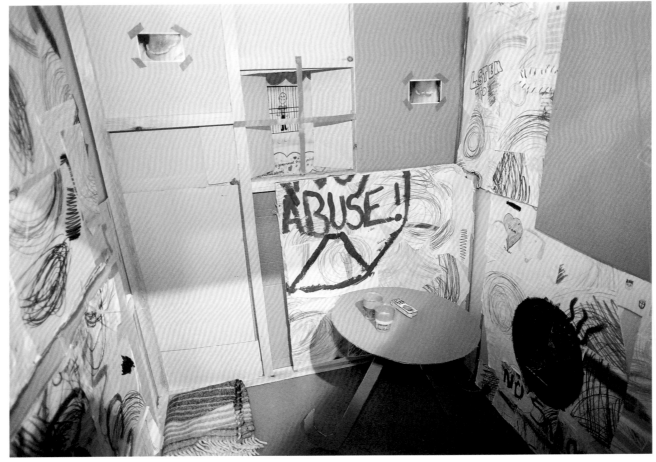

Childman

The other main work centred around the idea of a superhero. This was the work of one young person, and the artist developed the idea with him as a one-to-one collaboration. Through conversations and documentation, the boy designed the superhero's costume, how it would be displayed, and the content for a newspaper article based on Childman's rescue of a mother and her children from her abusive husband. This was an excellent development, as the young person involved had stopped coming to the main workshops but was very pleased to be invited to develop his work for the exhibition (see image p.32).

What worked

The staff at GWA were excellent and very supportive of the project. They attended regular monitoring meetings with the artists, and encouraged the young people to develop all sorts of interesting creative ideas, even though some of the young people were having a very difficult time at the refuge. This really helped the development of the project, and ensured that the artists were able to plan and respond to the needs of the group.

What was a surprise

The days in the park with the young people were really successful – those involved said they were the highlight of the project. Even lunch was art-based, with everyone making artwork out of the food provided, including lots of fun with icing pens!

What didn't work

In the beginning there were almost too many young people for us to develop initial ideas. They also were not able to come every week, and sometimes we needed to take time at the beginning of sessions to catch up on where the project was. Numbers fell due to other commitments, but out of those remaining a core group was established, and some powerful ideas and work developed for the final exhibition.

Comments

'I have learned a different way of looking at art and it was a lot of fun doing it.'
Participant, Glasgow Women's Aid

On the artists: 'They put such a lot of thought and effort in it and really valued the ideas and work of the young people.'
Children's worker, Glasgow Women's Aid

'I think it is a good thing because it was children that did all of this. If I had seen them the now I would give them rewards for this amazing piece of art.'
Visitor comment

'To everyone that made the exhibition. My favourite thing here is the shed. It's brill.'
Visitor comment

1 United Nations Convention on the Rights of the Child. Fact sheet *The Rights of the Child* available at www.unhcr.ch

Glasgow Women's Library

Duration

Project
February–December 2004

Exhibition
9 December 2004–
14 February 2005

Artists

Core artists
Rachel Mimiec and
Janice Sharp

Video edit
Cassandra McGrogan

Fanzine design
Karen Vaughan

Screensavers
Belinda Guidi

The group

Glasgow Women's Library (GWL) was established in 1991 and grew out of the women's arts-orientated project *Women in Profile* (1987), set up to ensure the visibility of women in the programming of Glasgow's year as European City of Culture in 1990. GWL provides information by and about women, and is a popular meeting place for women. Its creative, supportive environment acts as a catalyst for projects, friendships and laughter. It aims to provide and promote lifelong learning, training, education, skill-sharing, volunteering, and employment opportunities for women.

Process

Why we approached Glasgow Women's Library

GWL has played a major part in the history of activist work for the safety of women in Glasgow and has a strong visual arts focus. For these reasons we approached them to help develop *Rule of Thumb*, and they were represented on the advisory board. They also had a writer in residence with whom the artists could collaborate.

The project

At the start of the project, the artists gave a slide presentation on the issues involved in *Rule of Thumb*, incorporating a range of works from Glasgow Museums' collections and from contemporary artists. Women interested in developing work signed up at this session, and attended the workshops in the weeks that followed. The project developed slightly differently from other projects in that a series of workshops was developed round skills such as drawing, watercolour, bookmaking, storytelling and digital media. This was in response to requests from participants, and to address the fact that new people joined the group on a weekly basis, making it much larger than any of the other projects. New people joining made it harder to develop a core body of work from a single idea, but it did create a wealth of work to select from for the exhibition.

Women who participated at the Glasgow Women's Library were able to work with the resources there. The workshops encouraged women to respond to the library environment and to the theme; this included selecting book titles that held some resonance for them. This group generated a huge amount of work, so the artists held a selection meeting with them to discuss how and what work could be presented in an exhibition.

The result was a range of works that used the gallery spaces and the Library in the basement at GoMA. The spine poetry

and framed works were created during some of the early workshops, and the film of the sculptures in situ is an exciting document of the work in the library space. Their beautiful drawings developed a new resonance when animated and turned into screensavers for the computers in the Library at GoMA. This linked the exhibition to the library space at the Gallery and echoed the Glasgow Women's Library.

Work

Fanzine
Drawings, text and photographs generated from the workshop were collated into a photocopied publication. In keeping with the spirit of the Glasgow Women's Library and the power of homemade publications, this fanzine contained many of the words and images generated by the women during the project.

Screensavers (situated in the Library at GoMA)
Silhouette drawings that explored the idea of the self-portrait were animated and made into screensavers on the computers in the library at GoMA. Many of the drawings illustrated the women's personal stories through the use of symbolism and visual mind maps related to the themes in *elbowroom*.

Right: *Untitled*, pencil on watercolour papper. Photograph by Ruth Clark.

Below: Installation shot of film and bookshelves with fanzine. Photograph by Ruth Clark.

Installation shot of
Spine Poetry.
Photograph by Rachel
Mimiec.

Spine poetry and book installations

After selecting book titles that held
meaning for them, the women were
invited to photocopy the books' spines.
The resulting 'spine poetry' allowed the
women to make strong statements about
issues that concerned them. The work in
the library space was further developed
when books were used as the material
for making sculptures and installations
there. Dens, towers, abstract figures,
houses and carefully balanced
structures all became metaphors for the
women's concerns.

Image and text works

These artworks were created using
found text – text from random pages
from books located in the Library. The
women then selected phrases and words
that interested them and combined them
with drawing and watercolour painting to
create artworks.

What worked

The range of workshops appealed to the women, and the support of the group helped some of the women through a very vulnerable point in their lives. This meant that there was a lot of work to show, and this opened up GoMA as a building when we placed works in the Library as well as in the exhibition space.

What was a surprise

The work the group developed for the exhibition often had hidden references to violence against women – new people joined almost every week, so members took a long time to trust each other enough to discuss things more openly. The last session was exceptionally powerful, and opened up a lot of discussion which the artists found incredibly moving. This group went on to work with the GWL writer in residence developing new work for an exhibition which opened the same night as the *Barbara Kruger* show at GoMA, and four of the women worked with the artist in residence, Kevin Reid.

What didn't work

The numbers attending workshops were sometimes quite high, so the artists were often pulled in different directions. However, the body of work the women produced was lovely, and it was good to be able to show a subtle range of works on the issue, reflecting the women and the library they used.

Comments

'I enjoyed the company. The feeling of sharing of life. I came to the workshop with health problems, it took my mind off them.'
 Participant, Glasgow Women's Library

'It's powerful and good art but fun as well – thanks, it was fantastic.'
 Participant, Glasgow Women's Library

'The artists Rachel Mimiec and Janice Sharp worked extremely effectively with learners and users of GWL, many of whom are women in our priority groups, and significant outcomes have been recorded formally and anecdotally of their impact, significantly in relation to the impact on Adult Literacy and Numeracy learners who accessed the workshops.'
 Co-ordinator, Glasgow Women's Library

'This exhibition is fantastic. I loved the Women's Library Work, especially the book spine poetry idea.'
 Visitor comment

Spine Poetry.
Photograph by Rachel Mimiec.

Book sculptures in Glasgow Women's Library.

Red Road Women's Centre

Duration

Project
February–December 2004

Exhibition
9 December 2004–
14 February 2005

Artists

Core artists
Anne Elliot and
Rachel Mimiec

**Artists brought in during
the project**
Lesley Craigie and
Naheed Cruikshank

**Video documentation
and edit**
Kathleen Little and
Cassandra McGrogan

Opposite top:
Kites at Red Road.
Photograph by Anne Elliot.

Opposite bottom:
Labyrinth of Life.
Photograph by Women@play.

The group

Red Road Women's Centre (RRWC)
is in the north of Glasgow.[1] Its main
aim is to provide opportunities for local
women to relieve the isolation that can
be associated with living in high-rise flats
in a deprived area. This includes offering
access to, and information on, education
and training, health, welfare benefits,
legal services, and housing issues. The
centre also provides an advice/support
service, particularly for women in
crisis, on issues such as domestic and
sexual abuse. The centre is devoted
to implementing a holistic approach in
dealing with women's well-being.

Process

Why we approached Red Road Women's
Centre

GoMA had worked with the Red Road
Women's Centre on *Sanctuary*, the
previous social justice programme, as
many refugees and asylum seekers
had been housed in the Red Road
area. *elbowroom* presented us with an
opportunity to develop that partnership
further. RRWC were keen to be involved,
as they were interested in expanding the
resources they could offer to women,
especially those affected by abuse.

The project

Anne and Rachel gave an initial slide
presentation to women at the Relaxation
Group[2] of artwork by contemporary
artists on the theme of domestic
violence. At a feedback session, the
group decided they were very interested
in being involved in the project, but they
wanted to begin a new group rather
than build it into the structure of the
Relaxation Group. The best time for both
the women and the artists to meet was
early evening, and this had a profound
effect on the work they produced.

The project began with workshops
where the women used drawing, collage
and composition and got to know the
artists and each other. As their confidence
grew, the women instinctively started to
work together. The artists, realizing how
the group was forming and developing
ideas on violence against women, drew
their attention to the potential of the site of
Red Road as a backdrop to their activities.

The environment the Centre worked
in seemed like a symbol for some of the
issues in Scotland today: housing, poverty,
employment, ethnic diversity, alcoholism,
drugs, safety, broken homes and violence.
The very surface of the site the women
worked on was damaged, neglected and
dangerous, but the approach the women
took was a collective and positive one,
sharing experiences through the simple
act of play.

48

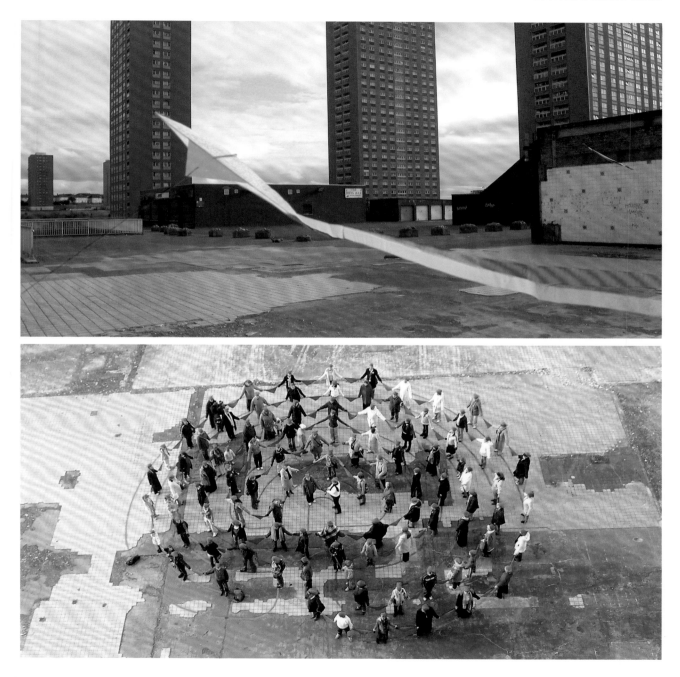

Installation shot of *Scarves and balls* for *Labyrinth of Life* event.

Each week the women chose an activity and played in the space, documenting this through photography and film. Out of these 'mini events' came the idea to create a large event for women to reclaim the damaged and neglected space outside the Centre. The group decided to become known as Women@Play, and worked under this name to develop and organize the event. It became known as the *Labyrinth of Life*, and the film of this event was part of the final work on show, as were the scarves decorated by the 100 women involved in the event.

Work

Women@Play film, including *Labyrinth of Life*

This film documented the project at Red Road and showed, through the simple and sometimes forgotten act of play, the women reclaiming the space outside the Red Road Women's Centre, generating powerful memories of simple pleasures. Having taken the name Women@Play, the group decided they would like to invite other women 'out to play'. As events managers, they made models, discussed options and then proposed the idea of the *Labyrinth of Life.*

The *Labyrinth of Life* became a metaphor for the journey women take through life. On Saturday 20 November 2004, over 100 women wearing red scarves came together to form the shape of a labyrinth below the Red Road Flats.

Opposite: Balls at Red Road. Photograph by Anne Elliot.

They were then invited to decorate their scarves with images and text related to their own personal journeys through life.

What worked

Although it was difficult in the beginning for the artists to bring up the theme of violence against women in workshops, the work in the exhibition was a very powerful contribution to understanding the issues. The women's response to play and create events in a very neglected site was indicative of the strength and unity of the group, many of whom were survivors of domestic abuse.

What was a surprise

The way the women came together as a collective was surprising, and they produced the most ambitious work of the whole project. The women's strength came from this way of working; what they were able to achieve in a very short space of time was incredible, as seen in the *Labyrinth of Life* event.

What didn't work

An enormous amount of work was generated for the women and for the artists, and the timescale involved was very tight. And although it all worked brilliantly, the extra commitment needed by the women involved was sometimes difficult for them to manage with all their other obligations.

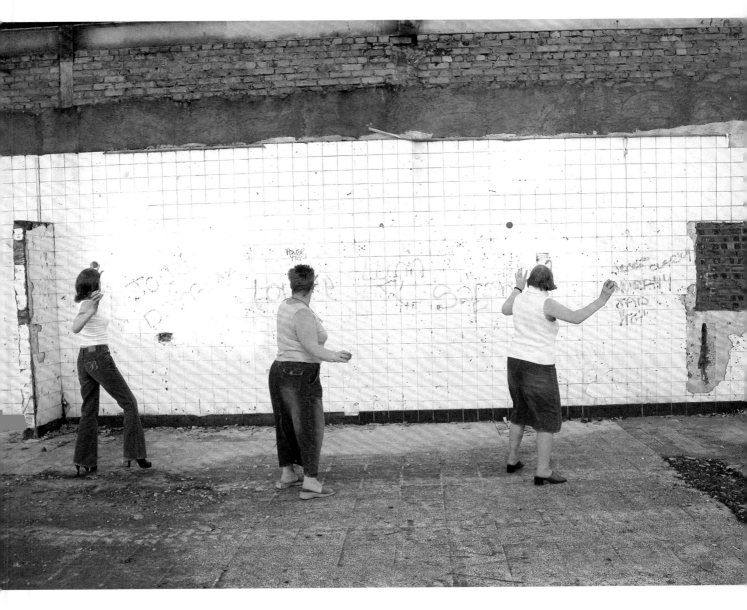

Comments

'I found that it helped my self-esteem and confidence and I found out also that I have an interest in art.'

Participant, Red Road Women's Centre

'Couldn't fault them – I would ask them to work here again in the Centre. They had a lot of understanding about the women, an ear to listen and were clear, considerate and showed empathy with the women.

The amount of women involved in the project was ideal. The way that the artists were matched to the groups worked brilliantly. Any time the artists did anything they took the Red Road Women's Centre into consideration. I didn't agree with everything, but I felt comfortable saying that. Other Centre projects haven't taken into consideration the other users and the Centre, but they considered everything, they covered it all.

I had to look at it from the women's point of view and say it. It wasn't always my personal point of view. I'm there for the women. But it was a great success, even the bank manager the Centre uses went in to see it with his friends and said to the manager of RRWC it was fantastic. The drop-in group went as well and they would never normally go to the Gallery. My husband's family went as well.'

Co-ordinator, Red Road Women's Centre

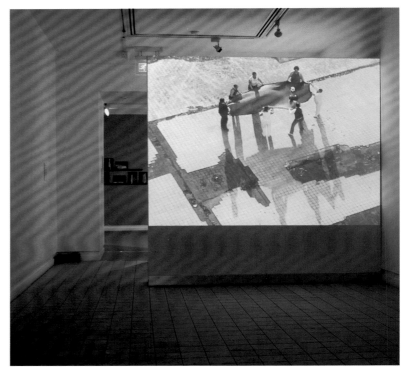

The Women@play film.
Photograph by Ruth Clark.

1 Red Road is a notorious housing scheme in Glasgow. When the 31-storey high skyscrapers were first built in the 1960s, they were the highest in Europe. There are 1,300 flats in eight tower blocks, and they are expected to be demolished over the next few years.

2 A group run for women who use the Centre who have been affected by abuse. The women discussed and developed a programme to suit their interests and the Centre facilitated it as far as they were able to.

2 Outreach Projects

An overview

Duration

9 projects
March 2005–January 2006

Exhibitions
….*it's just a domestic*
21 July–26 September 2005
Work in Progress
2–9 December 2005
*Rule of Thumb:
Contemporary art and
human rights, an exhibition
of work from the outreach
programme*
2 February–18 June 2006

Website
www.lw365days.org
launched in January 2006

Artists

**Core artists, writers and
musicians**
Madeleine Conn, Anne Elliot,
Magi Gibson, Jo Hodges,
Rachel Mimiec, James
Mclardy, Janie Nicol, Janet
Paisley, Jaki troLove and Aby
Vulliamy

**Artists brought in
to develop specific
aspects of the work**
Jennifer Beattie, Belinda
Guidi, Euan Hunter, Cath
Keay, Pervaze Mohammed,
Cassandra McGrogan, Jane
McInally, Michelle Naismith,
Jan Nimmo and Dawn Youll

The groups

Phoenix House, Aberlour Dependency Project, SAY Women, Young Women's Project, 281, Barlinnie Prison, North West Women's Centre, Greater Easterhouse Women's Aid, Meridian, Doorway and EVA (Ending Violence and Abuse). Most of these groups are involved in work relating to violence against women, although for some of them this issue is only relevant to part of their client base. For *Rule of Thumb* we worked with the women, men and young people who use these organizations' services. As with *elbowroom*, most of the participants had never been involved in art projects.

Background

Funding

During 2004 Katie Bruce secured core funding for outreach work from Glasgow City Council, with further funding of £20,000 from the Scottish Museums Council. Rachel Mimiec developed a project in partnership with EVA and Doorway which received funding of £1,500 from each of North and South Lanarkshire Councils.

Recruitment of groups

For the outreach projects we wanted to include organizations from all over Glasgow; this was later extended to include the two bordering councils of North and South Lanarkshire. We made a commitment to work with groups that we

had not had contact with before – generally non-gallery or museum visitors – and we also wanted to include a male perspective. Further suggestions came from people we were already working with on *elbowroom*, and other contacts were made through the *Rule of Thumb* advisory board.

As with *elbowroom*, the groups we approached worked with women affected by the issue of violence against women in its broadest sense: rape, prostitution, young people affected by the issue, survivors and those involved in campaigning and research. Groups not using the Museums Service, often deemed 'more difficult to engage' because of their vulnerability and isolation, were also identified and contacted, and we worked with a group of men in Barlinnie Prison. Katie Bruce made the initial approaches, sending out a project outline. Unlike *elbowroom*, these outreach projects were not limited to the visual arts but included musicians and writers. Many participants took this opportunity to try out an art form that they had not had access to before.

Selection of artists

We recruited artists in late 2004, via artist studios, the Scottish Arts Council, Art Net, direct mailings and through Glasgow Museums' website. We asked the artists to submit their CVs and examples of their collaborative work. Following interviews, we made the selection based

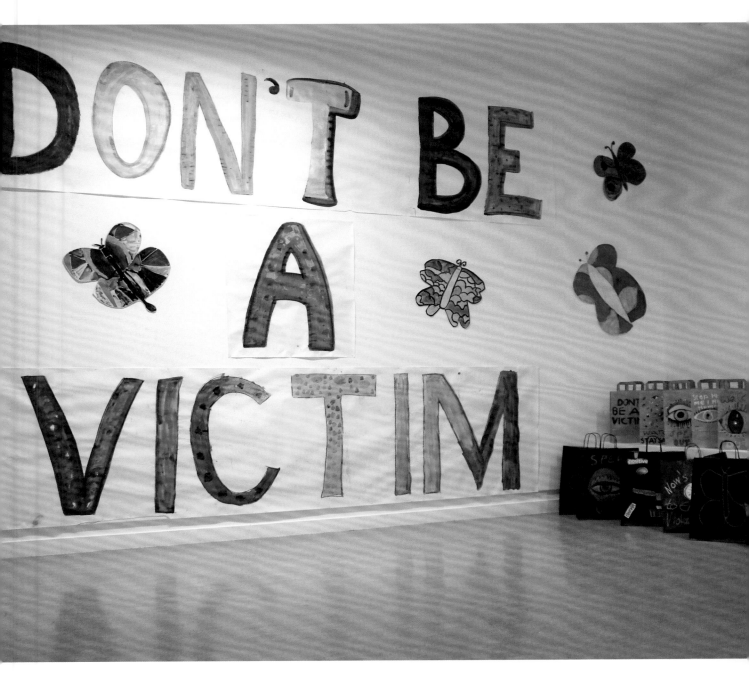

on artists' experience in collaborating with community groups and individuals, and the approach they would take. Janette De Haan again provided training for all the artists on issues surrounding violence against women, and monthly supervision meetings were set up.

Structure

The project

The structure for *Rule of Thumb* projects differed from *elbowroom*, mainly because we had ten artists working on nine projects across the city. We also did not have the same amount of funding in place for each project as we had had for *elbowroom*, and could only place one artist with each project (although we had money to bring in other artists as needed). Artists working on projects at the same time were able to meet up at the monthly meeting with Janette, but different start dates for projects and delays to meeting times and the structure of projects meant that artists were not able to work with the same cohesion that we had with *elbowroom*.

The projects ran for 16 weeks, usually meeting weekly in the venues where the groups were based. There was no predetermined outcome for any of these, and once ideas were established other artists helped to create specific works. Phoenix House was the first group to develop new work, and this was exhibited in GoMA from July to September 2005. The work from the remaining projects was shown in a joint exhibition on the balconies at GoMA from February to April 2006. Work was then returned to the organizations, and where possible, installed in their venues.

What worked

For artists Rachel Mimiec and Anne Elliot it was a good opportunity to further develop some of their experiences and contacts from *elbowroom*. These projects included writers and a musician, and this created opportunities for participants to explore the issue through different media. Often different art forms were used together, producing powerful works.

What we learned about how participants used the projects

Increased confidence and self-esteem

Participants and staff members felt an increase in participants' self-confidence and ability to speak out in groups. This was as a result both of their accomplishments in the group artwork sessions and of the group work itself.

An introduction to the arts and art galleries

Most of the participants had not taken part in any art activities before, and many said they would be interested in continuing to do some form of creative work. A large number also said that participating had encouraged them to visit GoMA, particularly those who had produced works that were to be exhibited there.

As a diversion

Those with dependency issues, and the men from Barlinnie Prison, said that it had helped take their minds off other things, and the exhibitions at GoMA were very important – 'another thing to do to keep me occupied/to stay distracted'.

Enjoyment

'It's the only thing … there aren't any deadlines or guidelines. No one's rushing you to get something done.'

Learning

For many of those taking part, these workshops were their first experience of learning something new for a number of years. Staff believed that this could act as a stepping-stone or gateway into further learning – many participants were interested in learning more and carrying on with their work.

Therapy

The emphasis placed by artists on expression and enabling participants to express their feelings more effectively had significant therapeutic value for some clients. Again, women used it for support to talk about issues that had affected them. They were then more confident about what they had achieved and spoke about it with others afterwards

What was difficult

Resources

Having only one artist per group was difficult when the groups were larger than expected. The artists all put in a lot of work, and participants and staff were very generous with their time.

Changing faces

Numbers changed and there were new faces each week in groups; this sometimes made developing ideas difficult. However, the groups and artists responded to this and worked towards exhibiting work that reflected the different collaborations.

Timescales

It would have been good to work with the organizations over longer periods in order to develop relationships and understanding about what could be created.

Comments and feedback

'Lot in my head as I drew what I felt and it helped.'

Participant, 218

'I look forward to it every week.'

Participant, Barlinnie Prison

'I'm just a prisoner, not an artist. But to maybe see my work in a gallery – that's an achievement in itself.'

Participant, Barlinnie Prison

'It shows people that they are not alone, that other people experience violence and it's not their fault.'

Participant, Phoenix House

Duration

Project
September–December 2006

Exhibition
*Rule of Thumb:
Contemporary art and
human rights, an exhibition
of work from the outreach
programme*
2 February–18 June 2006

DOMESTICA event
March 8 2006

Artists

Core artist
Anne Elliot

Other artists
Jan Nimmo and
Michelle Naismith

The group

218 is a recently established service
for women offenders. It is a structured
alternative to prison, addressing the
root causes of why women offend and
supporting women into a life of non-
offending. A residential project, it draws
on all disciplines to develop unique,
person-centred programmes.

Process

Why we approached 218

Staff in Base 75 had been part of
elbowroom and suggested 218 as an
organization we should approach. Initial
meetings with 218 project coordinator
Kirsten Jones led to our involvement,
and workshops were planned for Friday
afternoons.

The project

Because 218 is a residential project with
structured programmes, attendance was
quite high at workshops, and women
returned regularly. Ideas for the project,
focusing on the theme of domestic abuse,
evolved over the 16 weeks of workshops
held in 218 and in GoMA.

In the first session, Anne Elliot showed
work from *elbowroom* and by other artists
on the theme of domestic violence. She
had no preset plans, and as the women
had expressed an interest in drawing,
painting and writing, she began with
this. The project was documented in a
folder that the women had access to and

discussed each week. The women were
quite open about their lives, bringing
mixed experiences and views to these
initial workshops.

The work

DOMESTICA
The women's work developed into a 3-D
sculpture, and they used photography
and film to document it. They made
puppets and props with the help of artist
Jan Nimmo. The concept of a game,
DOMESTICA, emerged. In the Studio at
GoMA, the women and artist Michelle
Naismith developed the game's rules and
how it would be played. It is a life-size
interactive game in the form of a portable
installation, and deals with some very
difficult issues and stories. At the heart
of it are 'Chance' and 'Choice' cards,
scripted from the women's written texts,
recorded voices and researched material.
All this led to a video of an unrehearsed
performance of *DOMESTICA*, which was
shown in Gallery 3 at GoMA as part of
the exhibition *Rule of Thumb*. The rules
of the game were also exhibited, and the
game was played in public at GoMA on 8
March 2006 as part of the International
Women's Day events across Glasgow.

What worked

The game was an excellent way to bring
in the varying elements of work the
women had developed, and showed their
humour and creativity. Anne worked
very closely with the staff, in particular

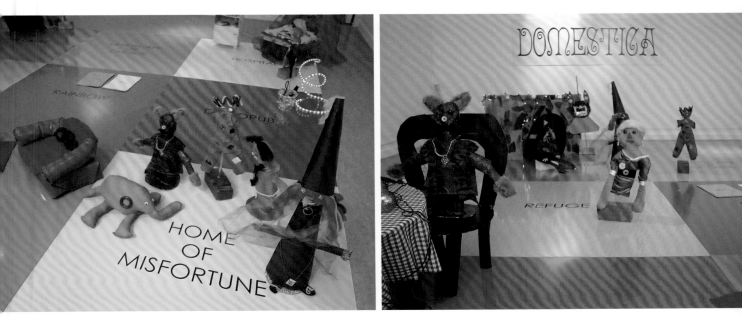

Installation shots of
DOMESTICA.
Photographs by Anne Elliot

with Janice Sullivan, who encouraged
the women when Anne wasn't there and
helped to develop ideas for workshops.

What was a surprise

The role of the 218 staff in developing
the work – this was a big project and their
help was crucial.

What didn't work

We found that the space at 218 was a bit
limiting and so we brought the women to
the Studio at GoMA. By this stage in the
project the women were more confident
about the project and were happy to
travel to a different space.

In some ways the project was difficult
to direct – the women were living very
chaotic lives and they only had this short
session once a week.

Comments

'Lot in my head as I drew what I felt and
it helped.'

Participant, 218

'It was very challenging to work to the
theme even with last year's experience
of *elbowroom*: aiming to involve non-
artists with many other priorities and
achieving a collaborative process with
them… I did develop my practice through
doing this project and I explored new
ways of working using new materials.
We developed a life-size game called
DOMESTICA which took the form of a
temporary installation and event with an
element of performance to video camera.'

Artist Anne Elliot

Aberlour Dependency Project

Duration

Project
April–September 2005

Exhibition
*Rule of Thumb:
Contemporary art and
human rights, an exhibition
of work from the outreach
programme*
2 February–18 June 2006

Artists

Writer
Janet Paisley

Artist
Belinda Guidi

The group

Aberlour's Glasgow Dependency Projects provide a residential and community-based rehabilitation service for women with dependency issues and their children. The projects aim to improve the life chances of children and families affected by drugs and alcohol, and to help women escape a cycle of alcohol and drug dependency. A weekly programme is created for each woman, and our project formed part of the group work undertaken by Aberlour.

Process

Why we approached Aberlour
Dependency Projects

We had worked with Julie McGee on *elbowroom* when she was a manager at Base 75. When she went to manage Aberlour's Glasgow Dependency Projects she was very keen for the women there to be involved in the *Rule of Thumb* projects. We worked with Julie to respond to requests for a writing group and to develop a project for women from two of their residential houses. (Although houses are residential for women and their children, this group was for the women only, allowing them space to explore ideas creatively without having to look after their children at the same time.)

The project

Writer Janet Paisley devised a series of one-off workshops so the women could build up a collection of short poems and stories. Initially the women kept their writings from these workshops, but some of the work was lost when women misplaced it or left Aberlour. Janet then began to keep photocopies of each week's work. She also set the group 'homework', based on ideas from the weekly session. These were read to the group the following week, introducing the idea of performance.

The group was voluntary and the women, although initially unsure whether to be involved, attended regularly. Because Aberlour is residential, some of the women left during the project and new women arrived; this altered the structure. However, by the end of the project a core group of four or five women were attending regularly.

Once a body of work was developed Janet introduced the idea of recording the piece 'Good word, bad word', which they had all written. This was recorded informally on a mini disk and a copy was made for each woman. Pleased with this, they decided to record a number of the pieces they had written. Arrangements were made with the Sevalas Studio (a recording studio in Glasgow) and four of the women recorded their work. This was made into a CD and copies were made for the women, the Aberlour

Right: Recording in the studio.
Photograph by Katie Bruce.

Below: *Pain.*
Courtesy of the artist.

PAIN

IT MEANS ALCOHOL STAPLES COMA IT IS THE COLOUR OF BLOOD
OR A BANG ON THE HEAD IT IS REMEMBERING THE NIGHT
WAKING UP WITH A PRIEST BY MY SIDE OR WITH THE SIGHT OF MY BRUISED
AND BATTERED HEAD AND FACE WHEN I LOOK IN THE MIRROR

THE WORD IS PAIN IT MEANS IT WAS SCARY

residential houses and GoMA.

Following on from this work, artist Belinda Guidi joined the group to work with them on producing posters based on their writing. Some of these were displayed in the exhibition at GoMA in February 2006.

Work

The women worked with Janet Paisley in a series of workshops to build up a collection of short poems and stories about their experiences, who they are, and about memorable events in their lives. These were recorded on to a CD, which was kept as a personal record of the work achieved.

Out of this writing and recording project came the idea to create poster artworks as a response to Barbara Kruger's style of working. Working with Belinda Guidi, the women produced powerful posters using photography, drawing, and Adobe Illustrator. These were printed and copies given to the women. The response was very good, and they were delighted with the outcomes of the project. Some of the posters were displayed in the exhibition at GoMA in February 2006, although permission for some works was withheld due to the personal imagery women had used.

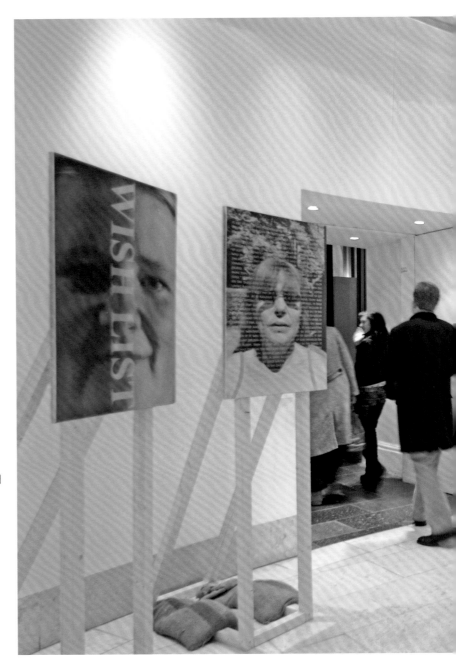

What worked

The two outcomes from the writing workshops – the CD and poster – worked very well. For the women, the experience of going to the studio to record their voices professionally was a great occasion and the CD was very well received. The posters meant the women had a strong presence in the entrance hall at GoMA.

What didn't work

Some of the women who had requested writing workshops left Aberlour, either before or during the project, and some of the women who joined the group were keener on visual art than on writing. However, although they had shown less interest in the writing workshops, they used the text they had written to develop the visual art aspect of the work.

Comments

'It made me face up to things, made me deal with it a bit better, than what I was'.

'I've dealt with the demon and put all that on the paper'.
 Participants, Aberlour Dependency Project

Barlinnie Prison

Duration

Project
September 2005–January 2006

Exhibition
*Rule of Thumb:
Contemporary art and
human rights, an exhibition
of work from the outreach
programme*
2 February–18 June 2006

Artists

Core artist
James Mclardy

Core writer
Magi Gibson

Opposite: Installation shot
from the exhibition.

The group

Barlinnie is a men's prison in Glasgow where remand, short-term and long-term prisoners are held. It has the largest methadone programme in Europe, a reflection of the serious drugs problem in the west of Scotland.

Process

Why we approached Barlinnie Prison

We wanted a male perspective on the issue of domestic violence, and initially contacted Alastair Low of the Men's Health Team in Glasgow. He recommended we work with Doris Williamson at Barlinnie Prison to develop a project. When we approached Doris, staff at Barlinnie were looking for a project which would appeal to the wide range of men involved in the LINKES education centre, and who would soon be discharged from prison. Doris's colleague Alexis McFadgen contacted other staff who proposed participants – the artists were not involved. (The men who were suggested were described as vulnerable in the prison environment, and staff thought that the project would help them to express themselves.)

The project

Alexis, the artists and Katie Bruce discussed where and how the project could work in a prison environment, and established what information would be needed before the project could begin.

Training for the artists was arranged, including self-harm awareness and resisting challenging behaviour. The artists agreed that workshops would take place on the same day. They expected no problems with attendance, as staff at Barlinnie were confident they could identify and support prisoners to attend. We also felt that by holding art and writing workshops on the same day we could perhaps develop a collaborative approach. The art forms might complement each other in the final exhibition; for example, a piece of visual art might provoke a piece of text, and vice versa.

At the first meeting, the artists presented the project to 15 men: six signed up for the art workshops, five for the writing, and four decided not to participate. Taking part in a creative project was a huge step for participants, and after discussion with prison staff and Katie Bruce, the artists agreed not to focus workshops on the issue of violence against women until they had engaged the men in the project and gained their trust. However, in the first writing and art sessions issues about women and relationships came up naturally.

Installation shot from the exhibition.

Due to conditions outside the artists' control, such as medication issues, appointments with other professionals, bad days, etc., there were only two participants at the first writing workshop and six at the art workshop. Both workshops continued for several weeks, and each week Magi (the writer) was told there were men who wanted to come to her workshops, but could not attend for various reasons. She was therefore only able to work with one participant, albeit closely, for a number of weeks. For the first time in his life, this man wrote poetry and short prose pieces. He then felt sufficiently confident and enthused to begin writing a novel.

Artist James Mclardy worked with the men using collage and creating images that sparked discussions about how men were presented and how they could be perceived. James introduced a number of skills and techniques, including drawing, composition, design development and sculpture. As the project progressed Magi decided to come in over Christmas (when James would not be in) and members of the art group said they wanted to come to the writing workshops. This proved successful, so the writing workshops were moved to a different day from the art workshops and attendance improved.

The men discussed the theme of violence against women. They were separated from the women they loved, were often intensely lonely and aware they had been less than perfect partners, and they expressed themselves in terms of love and loneliness. In the writing sessions, they discussed childhood experiences of witnessing and being affected by violence by their fathers against their mothers. However, as these highly vulnerable participants were struggling with many other emotional and personal issues, they were not ready to explore this in their writing. With more sessions, Magi felt she would have tackled the issue more directly, but it was necessary to build relationships of trust first and there was just not enough time.

At the end of the ten sessions the artists and participants attended a buffet lunch. The men were very happy with the outcome of the workshops, and desperately wanted them to continue. Art and writing had opened up new possibilities of self-expression that they were keen to hang on to. They discussed the exhibition and the work that would go into it. When the work was returned to Barlinnie it was either distributed to the participants or hung in the prison. Unfortunately, due to changes in the staff and the structure in Barlinnie, the project has not continued in this form, although other Glasgow Museums' initiatives, such as the Open Museum's day workshops, are running there.

The work

The work was displayed as an installation in the exhibition. The drawings and collages were framed and then hung amongst text written by participants in the writing workshops.

What worked

The results of the collaboration between writing and visual art were very powerful, and provided a different viewpoint on the themes raised by *Rule of Thumb*.

What didn't work

Unfortunately, some of the men wanted to attend both sessions and were not able to because of the initial structure of the project. However, after Christmas, when Magi was able to programme some sessions on different days, they could attend the writing sessions as well as the art sessions, and this was very positively received.

Comments

'I look forward to it every week.'

'I'm just a prisoner, not an artist. But to maybe see my work in a gallery – that's an achievement in itself.'

Participants, Barlinnie Prison

The Calendar Project

Duration

Project
October–December 2005

Exhibition
*Rule of Thumb:
Contemporary art and
human rights, an exhibition
of work from the outreach
programme*
2 February–18 June 2006

Website
www.lw365days.org
launched in January 2006

Artists

Artist
Rachel Mimiec

Website creator
Jennifer Beattie

The group

One of our most ambitious goals was to work with 365 women to create an online calendar marking significant dates in their lives. This project included North and South Lanarkshire Councils, liaising with EVA (Ending Violence and Abuse) – an organization in North Lanarkshire working mainly with women who are survivors of child abuse – and its equivalent project in South Lanarkshire, the Doorway Project.

The project
Why we worked with EVA and Doorway

Rachel's brief was to work with an organization outwith the city of Glasgow, looking at the themes raised by *Rule of Thumb*. After some research and guidance from the Women's Support Project, she met with Lily Greenan, co-ordinator at EVA, and presented the concept of an online calendar. This would be made by women who would select a significant date and then create an image that meant something to them on that date – it could be a piece of text, photograph or drawing.

Both North and South Lanarkshire Councils gave us supplementary funding to cover the extra costs of creating the website to help publicize all the resources available for women in Lanarkshire. With support from EVA, the Doorway Project and Cultural Coordinators in the Council, we circulated information leaflets through local resources for women. Rachel also contacted local women's aid groups and police services to involve as many women living in the region as possible.

Workshops were held and the drawings the women created were collected and documented by Rachel. The women were told when the website would launch, and gave their details to Rachel so we could invite them to the opening at GoMA and send them any information related to the project. Rachel then worked with Jennifer Beattie to develop the website, which launched in January 2006. The site was live throughout 2006, and during that time people could continue to contribute to the calendar.

Work

Women who lived or worked in Lanarkshire were invited to contribute images that expressed their thoughts or feelings about violence against women. Many, though not all, of the women who participated were survivors of male violence. Some chose significant dates from their own lives – a birthday, or the anniversary of leaving an abusive partner. Others chose significant historical dates, or focused on violence against women in a global context. The work included positive and uplifting images of hope, but also many that dealt with the true horrors of abuse and violence. Images were also made into postcards which were distributed in GoMA as part of the exhibition and used by the Lanarkshire Councils to promote the site.

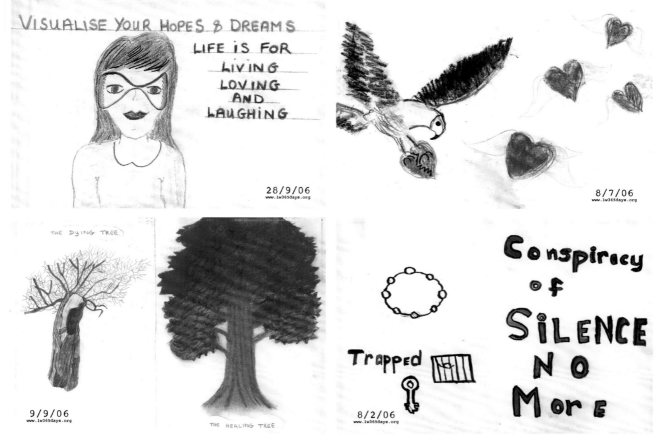

Clockwise from top left:
Images from the calendar, by
Anne McPhail, Sandra Toya,
Bethea Shilliday, Sarah
Rooney.

What worked

The website was an excellent format to
bring all the work of the calendar together,
and was accessed by people in more
places than we had originally imagined.

What didn't work

Some of the workshops were not well
attended. Initially we had thought about
holding general workshops that women
could come along to when they saw the
marketing. Although some women did
come to these, we found that the best way
to encourage involvement was by going
direct to the relevant organizations, and
Rachel began to do this towards the end of
the project.

Comments

'Many of the women who did participate
felt very strongly about making their own
personal statement and I was privileged
to meet and work with some extraordinary
women.'

Artist Rachel Mimiec

Greater Easterhouse Women's Aid

Duration

Project
April–December 2005

Exhibition
Work in Progress
2–9 December 2005
Rule of Thumb: Contemporary art and human rights, an exhibition of work from the outreach programme
2 February–18 June 2006

Artists

Artist
Jo Hodges

The group

Greater Easterhouse Women's Aid (GEWA) is one of four Glasgow women's aid organizations that provide support, information and refuge for women affected by domestic abuse.

Process

Why we approached Greater Easterhouse Women's Aid

GEWA had used art in a therapeutic sense before, but staff were interested in developing work with the women that would be displayed publicly.

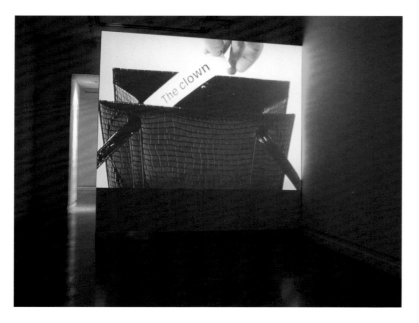

The project

Although these are residential projects, we felt that the meeting space at GEWA's main offices offered an opportunity for the women to meet other women in different surroundings. Artist Jo Hodges worked with the women there, and also organized trips to exhibitions of contemporary art. These included their first visits to GoMA and Tramway to see the Barbara Kruger exhibitions. This had a profound effect on the women, especially once they knew their work would be exhibited in the same venue (GoMA).

Work on the project progressed quite slowly as the women were often either in refuge or in the process of leaving. They needed to build up confidence in themselves and in the group, as they did not necessarily know each other. Some of them were coping with huge traumas, and groundwork was done to enable them to participate. Women often needed to take time out of the group to deal with the effects of discussing issues that had been raised in the workshops.

The initial workshops were spent looking at different digital media techniques and how artists communicate ideas, and the women used these sessions to talk and gradually gain confidence in working with Jo. At this stage, they explored digital techniques and produced photographs, short films and animations. Jo had created a handbag artwork for a previous

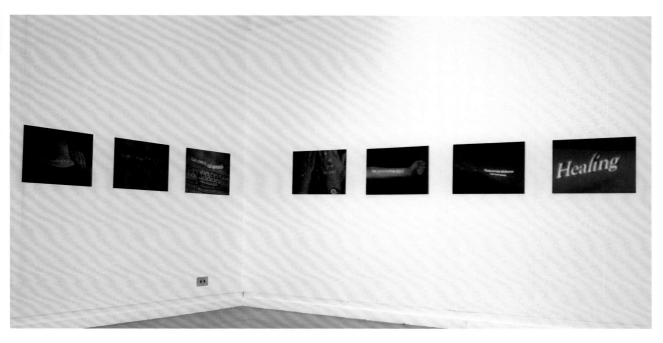

Illuminating Thoughts in the *Work in Progress* exhibition.

Opposite: Installation of *Handbag* film in the *Work in Progress* exhibition.

exhibition, and she brought this along to one of the workshops. This sparked various ideas – and lots of animated discussion – and the group then focused on using handbags to look at themes in *Rule of Thumb*. This developed into a film, and later the women decided to use handbags as the starting point to develop small installations (see p.72).

The group wanted to continue meeting as they recognized the value that it had for them, allowing them to share experiences in a safe space. Greater Easterhouse Women's Aid has built on the success of the group, and has developed the art group as part of their structured support programme for women. In 2006, the women won two prizes for their artwork in a competition to mark the 2006 UN 16 Days of Action.

Work

Illuminating Thoughts

The group created a series of photographs using light projected onto their bodies to reveal hidden thoughts and feelings on the abuse they experienced – making the invisible visible. This work enabled them to express the stages they were at in the process of recovery and change. It included statements and affirmations as well as questions, giving us an insight into their thoughts and feelings.

Handbag, shown in *Work in Progress*

In this film, women who had experienced abuse used a handbag to represent female personal space, inner thoughts, and hidden emotions. They bravely opened up this private space, gradually

Installation of *Handbags* in the exhibition.

revealing their thoughts and feelings – positive, challenging, painful and inspirational. Through this work they were speaking out and moving on.

Handbags, shown in Rule of Thumb

In this work, six women who had experienced abuse created handbags as an interactive representation of their personal space, inner thoughts and emotions. Each handbag reflected an aspect of their life and the process of recovery from abuse.

What worked

The women found visiting exhibitions very useful, giving them a chance to visit places they would not normally go to. The fact that they then exhibited their work in the same venue was a very powerful experience.

Introducing techniques gradually best supported the women in the group, allowing them to gain confidence and develop their own ideas.

Working flexibly was essential to this project; some sessions were put 'on hold' to allow group members to explore how they were feeling that day, and how they had been processing issues raised by the last workshop. Keeping a diary helped them continue developing work – this was like a sketchbook, not necessarily written, but holding pieces of work, images and ideas.

At the end of the project, the women hoped that other women in abusive relationships would see their work and

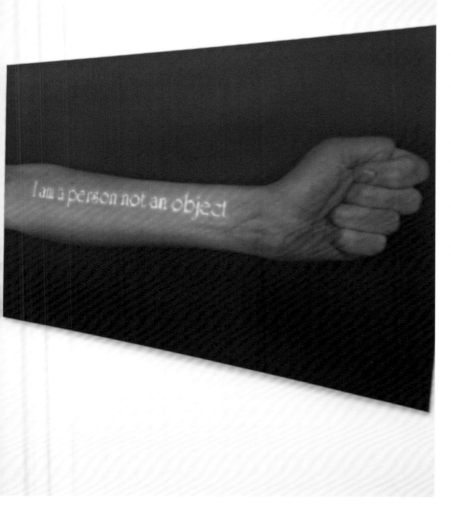

gain inspiration and hope for a different and better future.

What was a surprise

The group took a while to gain confidence, but once they did they were committed to the development of the handbags artwork. We had a very short time to pull this ambitious work together, and there was quite a rush to get all the work completed in time for the exhibition opening. However, the women worked really hard and made the deadline.

Comments

'Personally, it has been challenging, inspiring and emotional – and a privilege to work with the group, all of whom have been so deeply affected by their experiences of abuse. It was good to feel I had such a positive role to play in working with them to explore ideas, and ways of communicating them to other people.'

Artist Jo Hodges

Installation of *Illuminating Thoughts* and *Handbags* in the exhibition.

Meridian

Duration

Project
April–December 2005

Exhibition
Work in Progress
2–9 December 2005
Rule of Thumb:
Contemporary art and
human rights, an exhibition
of work from the outreach
programme
2 February–18 June 2006

Artists

Musician
Aby Vulliamy

Filmmaker
Jane McInally

The group

Meridian works with women from ethnic minority backgrounds, providing them with support and access to services, employment and resources in Glasgow. The women tend to use it as a centre for more formal learning, so Meridian welcomed the opportunity to develop more expressive workshops. Participants came from a number of different countries, and had lived in Glasgow for varying lengths of time.

The process

Why we worked with Meridian

Meridian were part of the advisory board for *Rule of Thumb*, and it was important to us that the views and experiences of black and ethnic minority women were heard. Their experiences – especially those of women who had come to Britain to flee violence – are sometimes overlooked because they are newcomers to Glasgow.

The project

Aby Vulliamy worked with the women at Meridian over several months, using a wide range of musical instruments. The groups changed each week because of personal circumstances or new people finding out about the project, so the sessions were quite fluid. Aby chose not to have a translator, so the women explored conversation and communication through music as well as with what English they knew. They were encouraged to explore sound and music, improvising together or teaching each other songs and rhythms from their birth countries.

Musical improvisation generated discussions and vice versa, and the sessions developed into a social space for the women to come together and discuss or sing about themes related to *Rule of Thumb*. In this safe space, they talked about violence, aggression, war, women's rights and domestic violence; motherhood, family connections, Mother Earth, home, origins, identity, beginnings and endings.

In the sound works they created specifically to be shown in the balcony galleries at GoMA, the women tried to imitate their improvisational social space. Sometimes individual voices were listened to, while at other times the interaction between the women and the communal voice they created was louder.

In addition to creating a sound piece, the women were also interested in

putting their music to film. Filmmaker Jane McInally joined the project in August to work with them to develop this. It generated new discussions about displacement and the women's experiences of this. They captured this in short bursts of film (similar to a family or a holiday video) with fragments of the music they had created in the workshops. The film was shown in GoMA as part of the UN 16 Days of Action, and at Meridian to generate discussion around women's human rights and the women's experiences in Glasgow.

With the group coordinator at Meridian, Aby established an ongoing music group as part of the services and opportunities offered there. Musical opportunities are particularly powerful in a multi-ethnic environment, and provide an excellent contrast to the skills-based courses, such as computers and childcare, that the centre offers.

Work

Film

The women made cultural and emotional connections through music, recognizing tunes and rhythms from their own country, or making links with their own personal or musical experiences. As the work progressed, they felt that their music, which represented the meeting of many different cultures, could be illustrated by a visual exploration of the place where the group came together – a Glasgow through the eyes of non-Glaswegians.

The video and music are chaotic, perhaps signifying the overwhelming sights, smells and feelings of a new and

Stills from the film *Untitled*.
Image courtesy of Meridian
and the artists.

unfamiliar place. But there are moments when the film feels calmer, when perhaps we begin making sense of things and find connections and possibly, even briefly, feel that there is a collective narrative holding the visuals and the music together.

What worked

The group enjoyed the informal learning experience, which contrasted with the other structured courses and sessions offered by Meridian. This came through strongly from the number of regular attendees, as other sessions were not as well attended.

One of the most important responses to the project was that the women asked for the music group to be developed as a permanent part of the programme at Meridian. This social, safe space and the music were very important for the women, and although they might not have left the house for other groups or participated in other arts projects, they valued the opportunity the music group had given them. It enabled them to discuss with other women issues which were often quite difficult, and when language could be a barrier.

What was a surprise

The film worked very well, and brought a new group of women into the project. The support of the centre was very important, and Meridian secured further funding to run an event as part of the 2005 UN 16 Days of Action.

What didn't work

The money to continue the project was difficult to obtain immediately, so Aby decided to work voluntarily. This was quite hard for her financially, but the commitment of the women encouraged her to run weekly workshops until Meridian secured further funding.

Comments

'The *Rule of Thumb* project felt very innovative – a model for building communication between communities and generating awareness and understanding of such challenging and widespread issues as domestic violence.'
Musician Aby Vulliamy

'It will be amazing for me to communicate in music with everyone.'
Participant, Meridian

Still from the film *Untitled*. Image courtesy of Meridian and the artists.

North West Women's Centre

Duration

Project
April–July 2005

Artists

Artist
Madeleine Conn

The group

North West Women's Centre (NWWC) provides a safe, women-only space, and a non-threatening atmosphere which gives women the opportunity to build up their confidence, skills and self-esteem.

Process

Why we approached the North West Women's Centre

We approached NWWC in the early stages of the *Rule of Thumb* project as possible partners for *elbowroom*, but were not able to develop a project at that point. However, as the Centre also supported a Tuesday evening group for young women and wanted to develop it, we thought a *Rule of Thumb* project could be a good starting point for bringing in more young women.

The project

We did a presentation to the group using slides of artworks on the themes raised by *Rule of Thumb*. The young women showed interest, so artist Madeleine Conn met with NWWC staff to discuss a structure and then began workshops looking at representations by, and of, women in contemporary art. They started by looking at the idea of whether language can legitimize negative attitudes towards women. The women created a piece representing a graffiti-covered toilet door, and developed storyboards that explored the story behind a piece of graffiti in which derogatory language was used about a girl. They also created collage pieces that exposed various stereotypes about women.

Following on from early workshops about collage, drawing and how images of young women are presented, the group developed ideas looking at characters affected by the issue of domestic violence. They made up scenarios of how they would react to given situations.

The women also had discussions and ideas about creating site-specific installations, and using memorials as a medium. After visiting the *Barbara Kruger* exhibition and *Voice/Over* they were very vocal with their opinions on the artwork and the issues raised, and seemed interested in developing their work.

We had to put the project on hold at this point because of the summer break, but feedback received by both the artist and the group leaders was positive. However, after the summer the young women did not return to the Centre. When staff talked to the young women's mothers it turned out that this was due to changes in school timetables or wanting to be with friends who were doing different things.

Madeleine and the Centre staff made various attempts to encourage new participants. This was largely unsuccessful – one reason was that the North West Women's Centre was under threat of closure and staff were fundraising and campaigning to keep it open. Eventually the project was cancelled, but we are maintaining links with the Centre in hopes that we can work together in the future.

It was disappointing for both parties that the project did not work out, but given the large number of groups we were working with, it is not surprising that some projects were not completed.

Artwork from a workshop.

Phoenix House

Duration

Project
29 March–6 July 2005

Exhibition
…it's just a domestic
22 July–26 September 2005

Artists

Main artist
Jaki troLove

Artists brought into the project
Cath Keay, Dawn Youll, Pervaze Mohammed and Euan Hunter

The group

Phoenix House provides specialist residential rehabilitation services for drug and alcohol users across the United Kingdom. Residents are both male and female, at various stages of their rehabilitation programme. We worked with the 'Women's Group', part of the strict programme for women living in the house in Glasgow. The group met on a weekly basis, and the women decided what they wanted to do.

Process

Why we worked with Phoenix House

When we worked with Base 75 on *elbowroom*, staff had mentioned the creative work happening at Phoenix House and suggested we contact them for *Rule of Thumb*. As we had not worked with them before, this seemed like the perfect opportunity to develop a link with their programme.

The project

This was the first group that we worked with on *Rule of Thumb*, and in some ways the most established as it met in a residential setting with a strict programme of activities and courses. The women had been involved in the gender group for some time, and from the outset had been interested in creating a sculpture. They were also used to supporting each other in the rehabilitation residence at Phoenix, so could discuss some very difficult issues and experiences. This helped the work develop into a very powerful piece.

Jaki worked with the women in several workshops where they tried out sculpture techniques. After several sessions, they developed an idea for an installation on the issues raised by the theme of violence against women. They visited GoMA to look at the *Barbara Kruger* exhibition and to see the space available for their work. After this visit, they adapted their installation so that it would work in the oval room off the balcony at GoMA. They spent the final workshops in the project developing the installation and creating elements of the artworks that would form it.

The group were keen to cast their bodies in wax. They spent a lot of time discussing domestic violence, and the experiences they spoke about were recorded. With Jaki, they selected phrases from the transcript of this recording, and these were used to cover the walls of the oval room, forming a very powerful part of the installation. The

Opposite: Cast of hand.

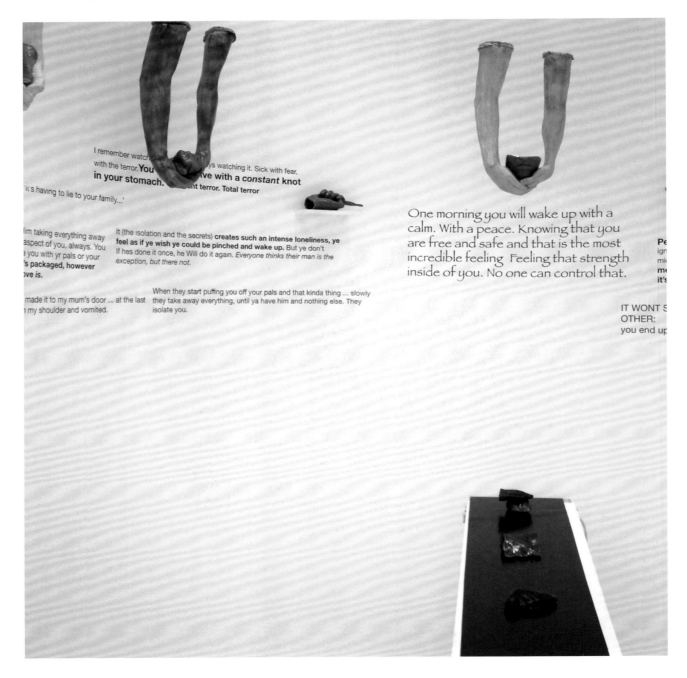

I remember watch[...] [alwa]ys watching it. Sick with fear, with the terror. **You** [...] [li]ve with a *constant* knot **in your stomach.** [...] [consta]nt terror. Total terror

[i]t's having to lie to your family...'

[H]im taking everything away [...] aspect of you, always. You [...] you with yr pals or your [...]'s packaged, however [l]ove is.

It (the isolation and the secrets) **creates such an intense loneliness, ye feel as if ye wish ye could be pinched and wake up.** But ye don't If hes done it once, he Will do it again. *Everyone thinks their man is the exception, but there not.*

One morning you will wake up with a calm. With a peace. Knowing that you are free and safe and that is the most incredible feeling Feeling that strength inside of you. No one can control that.

Pe[...] ign[...] mi[...] **me**[...] **it's**[...]

[...] made it to my mum's door ... at the last [...] my shoulder and vomited.

When they start putting you off your pals and that kinda thing ... slowly they take away everything, until ya have him and nothing else. They isolate you.

IT WONT S[...] OTHER: you end up[...]

exhibition was the first *Rule of Thumb* project to be shown in GoMA.

Originally we were only going to return the documentation of the work to Phoenix House, but because of the strength of the work and the response to it, Phoenix House decided to install the work permanently in their residence.

Work

....it's just a domestic

The women cast body parts that had been affected by violence in red wax and stuck them on a conveyor belt. This represented themes of cyclical violence and being trapped in a situation. When you looked further into the space at GoMA, the women's voices (in phrases from the transcript) were seen on the walls, a vivid reminder of the reality of domestic violence, but also sometimes offering a glimmer of escape.

Suspended from the ceiling were long latex arms which cradled those body parts which the women felt had acted as catalysts for them to leave. These were cast in the sky-blue wax of a fine, hot, free day, and represented the strength of the women, their survival and their hope.

What worked

The group worked very well together, creating an extremely powerful installation which they all felt part of. The phrases on the wall provoked incredibly powerful comments from visitors, and the exhibition was very well received.

What didn't work

The scale and ambition of the group's idea involved a large amount of commitment and time to make the individual pieces. This had an impact nearer the exhibition opening, as it was physically impossibly to involve the women in the installation of the work. Although lack of working space and of public liability insurance for the women meant that the group could not be there for the installation, at the opening they were amazed at how their work looked once polished and installed.

Comments

'At times the involvement in this project has been painful. Having to relive our fears and deal with our pasts… We hope the work that we've produced helps raise awareness for other women to come forward and seek the help they deserve.'

Participant, Phoenix House

Opposite and below:
Installation shots of … *it's just a domestic.*

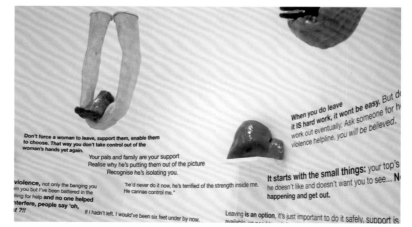

Young Women's Project and SAY Women

Duration

Project
April–December 2005

Exhibition
Work in Progress
2–9 December 2005
Rule of Thumb:
Contemporary art and
human rights, an exhibition
of work from the outreach
programme
2 February–18 June 2006

Artists

Core artist
Janie Nicoll

Video and edit artist
Alex Hetherington

Music
Gill Nicoll

The Open Museum
Chris Jamieson

Opposite: Still from the
fashion show in the *Barbara
Kruger* installation.

The groups

The Young Women's Project supports
vulnerable young women aged between
14 and 18, and runs a structured
programme for those who are referred
to the service. SAY Women works with
young homeless women aged between 16
and 25 who are survivors of child sexual
abuse, rape or sexual assault.

Process

Why we approached the Young Women's
Project and SAY Women

We were looking for organizations that
provided support to young women, and
made contact with SAY Women and the
Young Women's Project through the *Rule
of Thumb* advisory board. We already
had some links with both organizations;
we had contacted them about exhibiting
in the community exhibitions that ran
alongside the *Barbara Kruger* exhibition.
When we initially approached them, both
groups felt that a 16-week project was
too long for their clients, but a shorter
project would work better. We were also
considering a project involving working
with Glasgow Museums' collections and
the Open Museum, and felt that these
two projects could develop work into
an exhibition or resource that the Open
Museum could use in their programme.
(At the time of writing this is still in
development.)

The project

The structure for this project differed
from the others in that we initially held
two blocks of eight workshops in both
organizations, and Janie looked at ways
of bringing the groups together through
their artwork. Once the initial workshops
were completed, the ideas from them
were developed in further event-based
workshops.

Like several of the other projects, at
the first session Janie gave a slideshow of
Barbara Kruger's work, along with those
of other artists, as inspiration. Discussions
developed about dress codes and clothing
as protection, about arming yourself,
about being young and how masks can
be used for survival. This opened up links
to museum collections through the arms
and armour and masks collections that
were being stored at Glasgow Museums
Resource Centre, where the Open
Museum is based.

The workshops revolved around gaining
the confidence of the young women
and tapping into their interests: fashion,
music, mobile phone texting, being
young in Glasgow and how to be safe as
young women in a city. The groups were
very different; although the workshops
generally used similar processes, the
Young Women's project was much more
frenetic, with more participants and a
more energetic approach to the work.
The workshops for SAY Women had fewer
attendees and they were from an older age

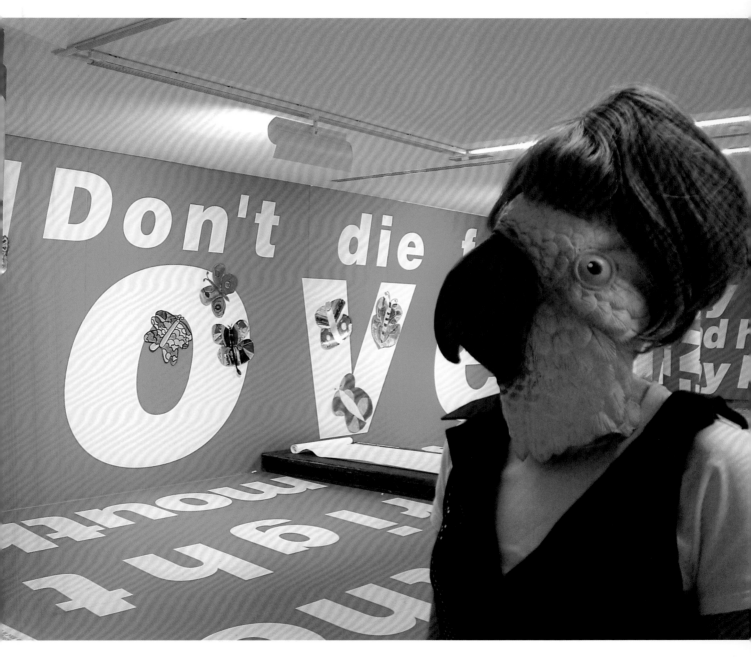

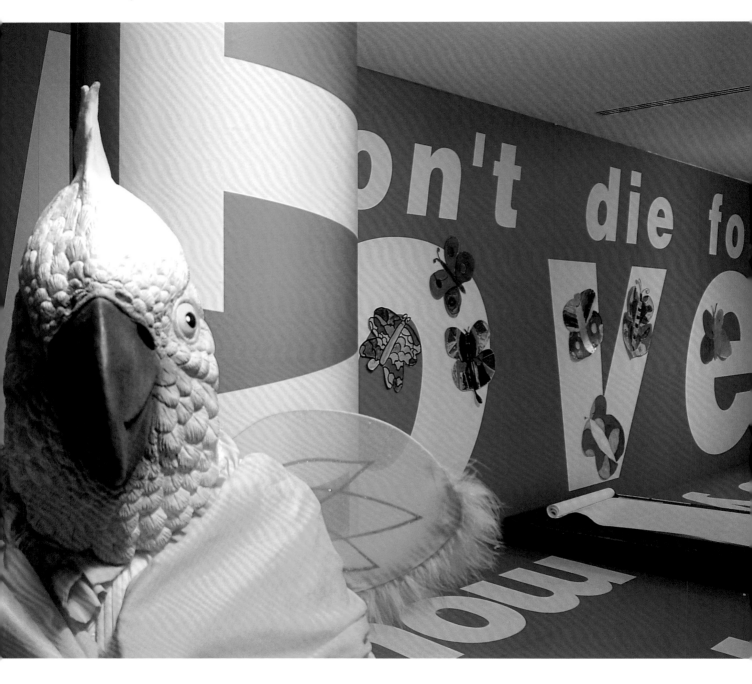

group, so Janie was able to focus the work on discussing and developing ideas.

Both groups produced a large amount of work, including customized fashion items: T-shirts, jewellery, hats, mirrors, badges and bags. Work from the projects were shown in two exhibitions – *Work in Progress* (T-shirts, jewellery, hats, mirrors, badges and bags) and *Rule of Thumb*.

Work

I'm Alive

This video work incorporated the range of artworks made during the project.

The film footage was developed by the artists and the groups, and involved filming at the organizations' premises and at GoMA. The session at GoMA took place in the *Barbara Kruger* exhibition space, where we set up a fashion show-style catwalk with a banner stating 'Don't Be A Victim'. (This was a phrase that had become particularly significant throughout the sessions.) The young people used the work they had created to customize the space further, using wigs, masks and clothes to hide their identity (because of issues of confidentiality), and to 'arm' themselves for the film.

It also contains footage of journeys from the outskirts of the city into the city centre, illustrating the draw of the glamour and nightlife that attracts young people, juxtaposed with graffiti and less glamorous aspects hinting at the dangers that also exist. In the video, animated butterflies move through the footage, symbolizing the movement and change that go on in the lives of the young women. In this 12-minute video, the imagery begins in a chaotic manner but then calms down in a way that reflects the lives of the girls, as they work with the organizations to improve their situations.

Once all the footage for the film was gathered, we approached both organizations for information that they felt should be included in a 'voice-over' to tie the elements of the film together.

What worked

The use of jewellery and clothing worked very well, and although at the beginning of the fashion shoot the young women were quite shy, by the end they were confidently walking up and down the catwalk and filming each other.

What was a surprise

We were lucky that when ideas were coming together for the work from this group the *Barbara Kruger* exhibition was finishing. We were able to film in the installation space and, even more powerfully for the work, the young women were able to graffiti the walls.[1] A number of the young women were gang members, used to marking their territory with 'menshies' or tags, and it was very moving to watch them write up their feelings or messages for other young women about violence rather than just their tag or 'menshie'.

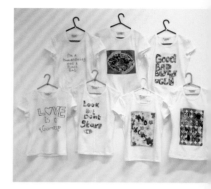

T-shirt designs.

Opposite: Still from fashion show in the *Barbara Kruger* installation.

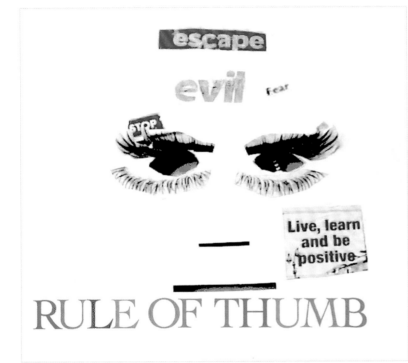

Above: Mask developed in
one of the workshops.

What didn't work

By the time we came to develop
the projects in the second block of
workshops, a number of the young
women had left the project – this was
a common problem when working with
younger groups. It meant that some
women had not been involved in the
earlier stages, but they embraced the
ideas that had been explored earlier and
added their own.

Comments

'Different from other groups I have
attended.'

'Good to get out of the Unit.'
Participants, Young Women's Project
and SAY Women

Below: Still from *I'm alive*.

1. Barbara Kruger had left instructions for the installation
to be destroyed once the exhibition was over, so we were
able to work on the wall space installation before it was
disposed of.

3 Partner Projects

Organizations

Glasgow Women's Library, SAY Women, Scottish Women's Aid, Women's Support Project, Young Women's Project and Youth Services – Girlz in Da Hood

Exhibition

Voice/Over, 20 April–3 July 2005

The organizations

Glasgow Women's Library (GWL), established in 1991, provides information by and about women (see p.44).

SAY Women works with young, homeless women aged between 16 and 25 who are survivors of child sexual abuse, rape or sexual assault (see p.84).

Scottish Women's Aid provides counselling and a safe house for women and children who have been abused.

Women's Support Project is a voluntary organization that works against violence against women and children, highlighting the links between different forms of male violence and promoting an interagency response to abuse.

Young Women's Project supports vulnerable young women aged between 14 and 18. They run a structured programme to support those women who are referred to the service (see p.84).

Youth Services – Girlz in Da Hood was a group of 11- to 19-year-old Glaswegian Asian girls. Working with Glasgow City Council Youth Services, they discussed issues affecting their personal lives.

Still from *noctuary*, shown in *Voice/Over* exhibition. Lotta Petronella and Raman Mundair (GWL).

The exhibition

Voice/Over displayed artwork from key organizations that work with women and young people, addressing the theme of violence against women, children, and young people. In this project, the women from GWL who had worked with GoMA on *elbowroom* continued to develop their body of artwork with films and an installation. They later went on to work with GoMA's artist in residence, Kevin Reid (see pp.106–107).

In collaborations with film companies, individual filmmakers and writers, women, children and young people used film, text and collage to create powerful works expressing their opinions on issues such as domestic abuse, rape, bullying and forced marriage. The exhibition opened on the same night as the *Barbara Kruger* exhibition, giving a voice to a number of women and young people affected by the issue of domestic violence.

Still from *stations*, shown in the *Voice/Over* exhibition. Jaki troLove and Louise Shambrook (GWL).

Project

I Love You Numb
17 and 19 September 2005,
The Arches, Glasgow
29 September 2005, North
Edinburgh Arts Centre

The organization

Cat in the Cup is a theatre company that works with community groups to develop new pieces of theatre.

The process

Cat in the Cup contacted Katie Bruce with a proposal for a theatre project, *I Love You Numb*. This was a collaboration with young people and the experimental electronica band 7VWWVW, aimed at audiences aged 14 and over. We decided to give Cat in the Cup a grant because the performance's themes of mental ill health and perceptions of this fitted within the parameters of *Rule of Thumb*. The project specifically investigated the effect that abuse and neglect at home has on young people and their mental health.

I Love You Numb explored the story of the fictional Katie Anne, who grew up in residential care after being abandoned by her mother. Although she had always been told that her mother had neglected her, she later discovered that her mother had been mentally ill. This helped Katie Anne come to terms with the abuse that followed, and helped her to try to overcome her own depression.

Workshops for young people aged between 16 and 25 were held in Glasgow and Edinburgh. They developed their performance skills, and were involved in rehearsals to form a community chorus. The play was performed in Glasgow and Edinburgh.

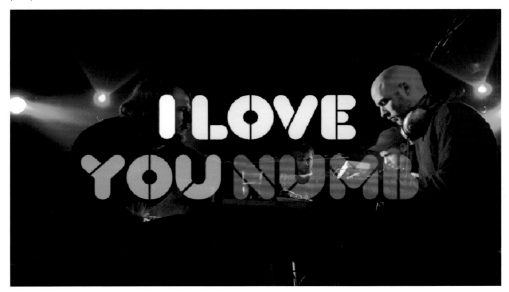

Publicity still from *I Love You Numb*.

Museum of Transport

Project

Reflections

Project Co-ordinator

Louise McDermott

Artist

Jane McInally

Writer

Janet Paisley

The project

The aim of the *Reflections* project was to build the skills and self-confidence of women with whom the organization Routes Out of Prostitution was working. We held 16 sessions, including workshops at the Wayside Centre (a centre for homeless people) and visits to Glasgow Museums' venues.

Structure

With writer Janet Paisley, artist Jane McInally and Glasgow Museums Learning Assistants, the women used museum collections to explore the theme of 'women'. In early workshops we experimented with writing exercises, animation, drawings and collage. Ideas for final works were discussed, and the women decided to work as a group to create one large wall piece.

Documentation of this project included individual diaries kept by the women and a DVD of the workshops. These were displayed alongside the artwork from the sessions and the final wall piece. The exhibition opened at the Museum of Transport during the UN 16 Days of Action for the Elimination of Violence Against Women in 2005.

Maureen with her mask.

What worked

We were delighted that by the end of the project, we had achieved all our aims. These were to:

- facilitate discussion on women's issues;

- introduce women from Routes Out of Prostitution to Glasgow Museums and provide access to our collections and venues;

- encourage self-reflection, self-expression and confidence as a first step on the road to taking part in the discussion group;

- introduce the women to techniques for creative writing, art/graphics and photography/video.

Above: Pauline.

Below: Raz.

Diaries

We made sure that in every session participants had time to think and to write about their feelings. We bound these reflections into a book and gave this to them at the end of the project. As well as encouraging self-reflection, this also gave the women an opportunity to comment on sessions without worrying about offending staff (although they were verbal enough if they liked or disliked something!). This gave us solid feedback that we could use as part of the project evaluation. However, further time for Louise McDermott to evaluate the project in line with GLOs[1] (generic learning outcomes) would have been valuable. From our post-project interviews with participants as well as from their project diaries, we know that the project had a positive impact.

Workshops

The workshops stood both as standalone sessions and as part of a series. The structure of the programme meant that workshops were focused, held regularly, and it was always made clear what was happening and when – this was very important for participants. Although attendance on certain visits to Glasgow Museums' venues was low, overall the turnout was very good. This may have been because participants saw the main venue, the Wayside Centre for homeless people, as a 'safe place'. And although at the beginning of the project the

women had said they were not interested in museums, they later developed a real interest in going. By the end of the project, most of them agreed that they would continue to visit – this was perhaps because they had become familiar with museums through workshops, but also because their work had been displayed in an exhibition, something they were very appreciative and proud of.

What was a surprise

We were actually surprised that the project worked as well as it did. It not only achieved its aims, but also had a big impact on participants, staff and volunteers. We were surprised at the effects of the writing workshop particularly (both staff and participants were moved by it), and at the levelling and bonding it produced across the group.

What didn't work

Partnership

We didn't implement partnership agreements or set up formal evaluation and discussions at the end of the project. This might have helped the staff at Routes Out of Prostitution define their roles in the project. Although their staff came to some sessions, they were not able to attend regularly due to their work commitments and this had an impact on the project itself. Reflecting on the project, we felt that if their role had been better integrated, perhaps more women would have gone on to post-project lifelong learning.

Sustainability

As far as we are aware, the Wayside Centre has not been involved in any subsequent projects, although they were very keen to continue working with Glasgow Museums. Unfortunately, time constraints have prevented this to date.

Participant at a *Reflections* workshop.

1. Generic learning outcomes – a system of using five general groups of learning outcomes (knowledge and understanding; skills; attitudes and values; enjoyment, inspiration, creativity; and activity, behaviour and progression) to categorize the personal learning outcomes experienced by users of museums, archives and libraries.

Tramway

Project

Barbara Kruger/*Twelve*
Education Project
With Bow and Drill

Artists

James Mclardy and
Belinda Guidi

Exhibition duration

21–26 September 2005

'One of the themes in Barbara Kruger's *Twelve* is the idea of the dissolution and abuse of boundaries and territory – personal, physical, emotional, artistic, social. Many of the conversations portrayed in the work start somewhere but end somewhere else. The viewer watches as the boundaries between those involved dissolve and shift or we gain access to the internal mechanisms involved when someone's own personal boundaries – and self-respect/sanity – are under threat. I wanted to explore this theme with a group of teenage boys at a time in their lives when issues of boundaries and territory become increasingly relevant.'

Lorraine Wilson, Visual Arts Officer,
Tramway

Installation shot of *With Bow and Drill*.
Photograph by James Mclardy.

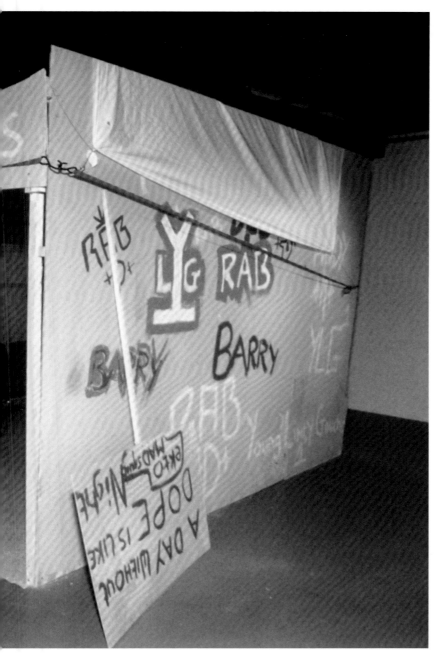

The organization

Glasgow's Tramway is one of the leading contemporary visual and performing arts venues in Europe.

The process

Artists James Mclardy and Belinda Guidi worked with a small group of teenage boys who were at risk of offending and who exhibited challenging behavior or had drug and alcohol problems. By taking part in activities run by group leader Sarah Brown, the artists gained the boys' confidence.

Working with the idea of boundaries and territories, James and Belinda found that the concept of 'den' was a way of connecting with the young men – it was something they could relate to. The group decided to build a den or 'hideaway' in the Project Room, the exhibition space at Tramway. They would be in complete control of its design, building and furnishing.

In the week before the exhibition opened, the group built the work in the Project Room. We held a small launch on 21 September 2005, and Tramway staff, the artists, the group and one of their teachers attended. The installation was open to the public for the last six days of the Barbara Kruger exhibition *Twelve*, and both were deinstalled on the same day.

What worked

The project managed to capture the attention of the group after a period of uncertainty. In the end we found ways to focus the boys' energy using the physical action of building a personal space, resulting in a real sense of collaboration.

What was a surprise

'At Tramway we all came together and it worked. Everyone put a lot of raw emotion into the construction of the den. Sculpturally I felt the final structure captured/possessed some of the dynamics of the group.'

Artist James Mclardy

What didn't work

'There were times at the beginning of the project where the group felt quite threatening. It was very difficult to work with them, and there was a lot of disruption; an otherwise normal workshop environment was impossible. This was partly because a workshop environment was probably a bit like school, and also because there were a lot of other young folk hanging about outside. We followed this with an unscheduled trip to an area of wasteland where the boys liked to hang around – this is where we began to discuss the possibility of making the final installation.'

Artist James Mclardy

Installation shot of *With Bow and Drill*.
Photograph by James McLardy.

4 **Barbara Kruger:**
The exhibition

The exhibition

Ben Harman, Curator, Contemporary Art

'The power of art must be harnessed for change and there is so much power in this exhibition. If only all men got to see it and just as importantly women, as its power may at least be used by them to change their circumstances. Thank you – I am deeply moved.'

Visitor comment

It is proven that the perpetrators in the majority of incidences of violence against women are men. For this reason I was aware of the sensitive nature of my position as a male curator leading an exhibition on that subject. With advice and support from GoMA staff and the *Rule of Thumb* advisory board, potential difficulties did not arise – my curatorial decisions were made with the full support of the advisory board, and they in turn provided me with information and statistics on the issues relating to violence against women.

For this six-month-long exhibition on the theme of violence against women, I selected a solo artist to differentiate it from the group format of 2003's *Sanctuary* exhibition. I drew up a list of artists from Scotland and abroad, but was particularly interested in those who had never exhibited in Scotland. I knew that the first presentation of an artist's work in Scotland, particularly one with an established international reputation, would be an excellent way of attracting visitors and raising the profile of the topic.

Barbara Kruger, an American artist well known for her work on the subject of women's rights, was top of my list. Despite her international reputation, she had never exhibited in Scotland, so in May 2004, I invited her to exhibit at GoMA. From that first point of contact, Kruger made it clear that it was the theme that attracted her to the project. She was particularly enthused by Amnesty

International's support for the exhibition, explaining that such collaboration 'would never happen' in the USA.

Kruger visited Glasgow in October 2004 to assess the gallery space and to discuss the exhibition and our *Rule of Thumb* programme. In addition to the gallery-based exhibition, we talked about the possibility of using billboard spaces in Glasgow city centre for her work. This was something she had done before, as a way of reaching the public outside galleries and museums. For the GoMA exhibition, Kruger decided to produce a new 'gallery wrap' installation that would cover the walls, floor, columns and skylight window areas of Gallery 4.

On returning home to the USA, she asked us to send her two things that would be essential to the production of her artwork: exact measurements of the gallery space, and cuttings from UK magazines and newspapers relating to the topic of violence against women. She worked with a company in Los Angeles to create digital artwork for the installation – this was burnt to CD and sent to Glasgow to be output. The graphics were printed on to a robust, self-adhesive, vinyl material that visitors could touch and, on the gallery floor, walk on. It was the biggest single vinyl order that the graphics company had ever received, and the whole exhibition took two technicians four days to install. Barbara Kruger was able to return to Glasgow for the last few days of the installation to advise on the finishing touches.

Barbara Kruger installation view, Gallery of Modern Art, Glasgow, 2005.
Photograph by Ruth Clark.

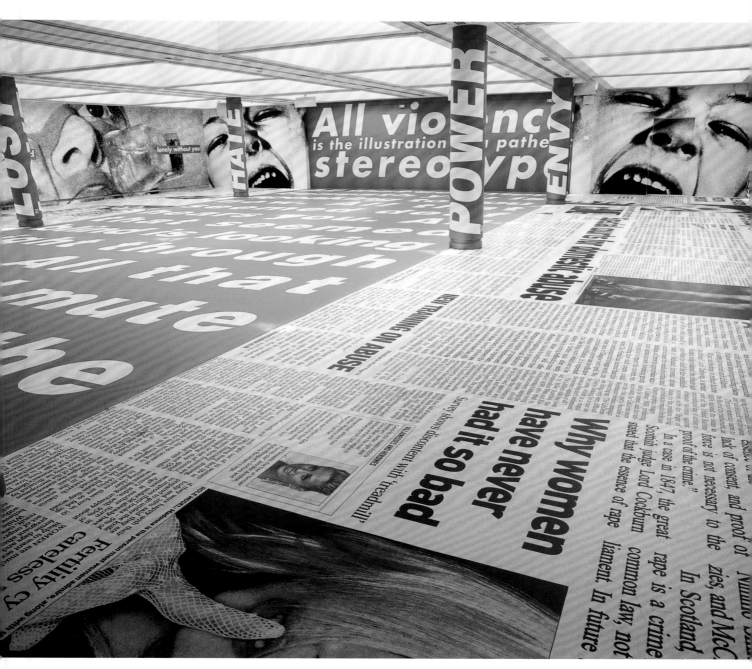

Barbara Kruger

'Speaking as a man, I thought the exhibition was excellent in highlighting violence to women and zero tolerance. Also, how many noticed the windows above, show how much is around us we choose not to see. Well done.'

Visitor comment

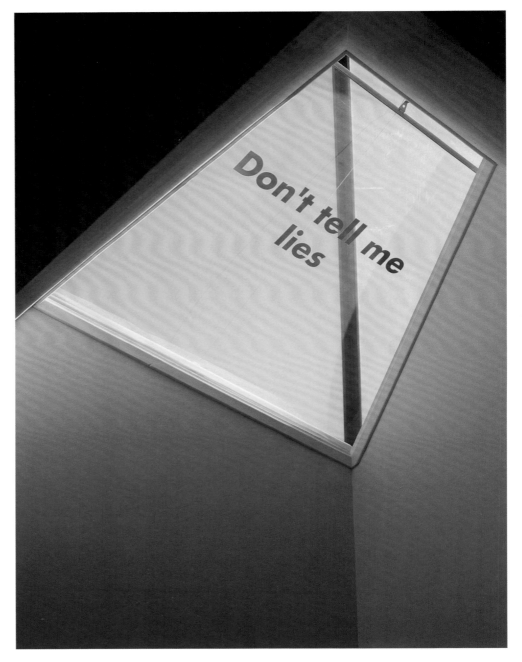

Barbara Kruger installation detail, Gallery of Modern Art, Glasgow, 2005.
Photograph by Ruth Clark.

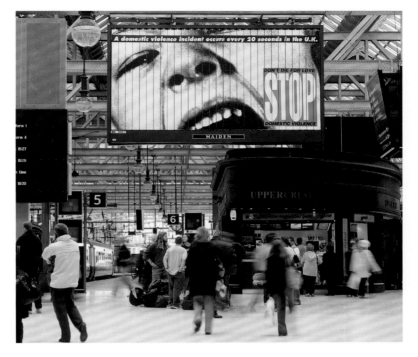

Billboard artwork designed by Barbara Kruger and installed at Central Station, Glasgow, 2005. Photograph by Ruth Clark.

The graphics consisted of Kruger's trademark texts in Futura typeface over black and white images. Unusually, she chose a green background colour for the artwork, rather than her usual red. This was a deliberate decision, as she felt that red would make visitors less likely to linger in the installation. The choice of green (a colour often associated with Celtic Football Club, Ireland and Catholicism) was not a reference to sectarianism in Glasgow although, when Kruger was told of the significance of the colour green here, she was intrigued that such a colour could provoke hatred or vandalism.

The magazine articles and newspaper cuttings that we had sent her were reproduced, larger than life size, on the gallery floor for visitors to read. (We were delighted that all the publishers involved were happy to grant permission for this use.) Images and words covered the walls, floor and columns of the gallery, and the blinds on the skylight window spaces had phrases such as 'Don't tell me lies' printed on to them. Kruger's own texts echoed the voices of the victims and perpetrators of violence against women. The issue literally surrounded and enveloped you when you entered the exhibition.

In addition to the installation at GoMA, Kruger produced artworks that were used to advertise the exhibition and to raise public awareness of violence against women. These included written

statistics such as 'A domestic violence incident occurs every 20 seconds in the UK' and '1 in 4 women is a victim of domestic violence at least once in her lifetime'. They were used in adverts in magazines and newspapers, and as posters at bus stops and subway stations. To complement the marketing campaign, we booked a billboard for a month in Glasgow's Central Station (one of the busiest stations in Scotland), to display an artwork. We also produced a catalogue as a record of the exhibition.[1]

In August 2005, Tramway, one of the leading contemporary visual and performing arts venues in Europe and also based in Glasgow, presented Kruger's recent massive video installation, *Twelve*. This coincided with GoMA's exhibition of

'Something so powerful and strong about this exhibition, it has made me open up my eyes to what my ex-boyfriend has put me through.'

Visitor comment

her work and was the first collaboration of its kind between us. Crucially, the unique character of the gallery space at Tramway allowed *Twelve* to be exhibited at its intended size for the first and, to date, only time.

We had over 300,000 visitors to GoMA for this first exhibition of Barbara Kruger's work in Scotland. Written comments from gallery visitors and journalists were extremely positive and moving. The images that Kruger produced for the exhibition have been used in other campaigns, in places as far apart as Edinburgh, Finland and Australia, to raise awareness of violence against women. She has kept in touch with the staff at GoMA, and the exhibition is now a key reference point in the talks she delivers to students and arts professionals around the world.

1 B Harman, 2005, *Barbara Kruger*, Glasgow: Glasgow Museums.

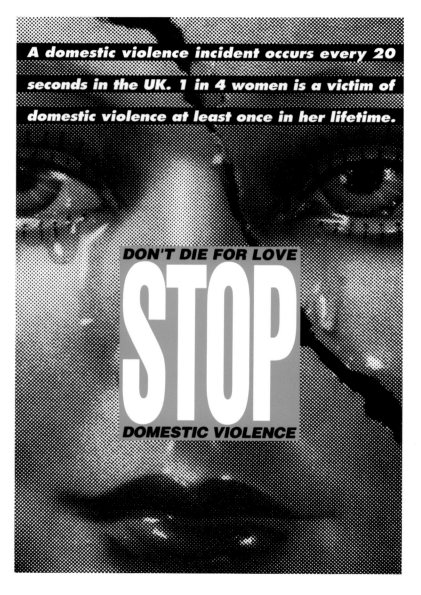

Poster artwork designed by Barbara Kruger for the Gallery of Modern Art, Glasgow, 2005. © Barbara Kruger.

5 Education & Access
The *Rule of Thumb* programme

The *Rule of Thumb* programme

Alicia Watson, Education & Access Curator

'The artist could really connect with people... He took time to get to know people and what they wanted from the project. He was a very good role model for men. He changed my opinion a bit and got me thinking that maybe there are good men out there. He was the first connection that I have had with a man who is not a blood relative.'

Residency participant

Response Space for *Rule of Thumb*.

The *Rule of Thumb* education and events programme ran in tandem with the *Barbara Kruger* exhibition at GoMA. The Education & Access (E&A) team concentrated on three main areas: the Response Space; an artist residency; and an accompanying schools and events programme.

Our E&A team consists of one curator and two Learning Assistants who develop the events and workshops accompanying the social justice programmes. We also run the regular formal and informal education programmes that take place throughout the year – our schools provision, a regular workshop series, the Saturday Art Club, and talks and events for families, adults and young people. Where possible, we use the social justice programmes to enhance and expand these, enabling us to attract, reach, and hopefully maintain, new audiences.

The Response Space

We developed the Response Space because of comments from the advisory board and visitor feedback from the *Sanctuary* exhibition in 2003. This was a relaxed and informal space where visitors could reflect and respond to what they had seen, and to the issues raised by the exhibition. Soft seating and carpeting encouraged visitors to take time to linger, reflect and find out more. In this area we put a plasma screen showing a video of the installation of Barbara Kruger's exhibition, information leaflets from relevant organizations, related publications and catalogues, information on websites, audio recordings of personal views and experiences,

statistical material and an interactive response wall. Here visitors could write down their opinions and stories on long strips of white paper. These were then twisted into 'ribbons' – representing the symbol for the UN 16 Days of Action for the Elimination of Violence Against Women – and pinned onto the wall.

The Response Space has become an integral part of our social justice programmes, and is heavily used by visitors.

The Residency

Throughout June 2005, GoMA played host to Kevin Reid, our first artist-in-residence. We wanted to find an established visual artist whose previous work had addressed issues of social justice, and offer them the opportunity to create new work at GoMA. Kevin was invited to work with a women's group and also to produce his own work in response to the *Rule of Thumb* programme. We had no predetermined outcomes in mind, and did not set any parameters for the project.

Kevin worked with a small group of middle-aged women from Glasgow Women's Library over a four-week period. They looked at ways of addressing and raising awareness of the issues of violence against women through art. In discussion and workshops, they came up with the idea of staging a kind of anti-violence demonstration in public.

The women developed the slogan 'NON-VIOLENCE' and a logo for this, as well as badges and T-shirts. They built and manned a purpose-built booth that was used as part of an intervention in front of GoMA on Saturday 2 July 2005.

The women offered passers-by free badges and asked them to fill out a label stating how violence had affected them and how violence could be stopped. The group gave out over 700 badges, and leaflets and information from support groups including Amnesty International, Women's Aid and Glasgow Women's Library were also available from the booth. Before the booth was dismantled and the public intervention ended, the women chose 100 of the completed tags, attached them to helium balloons, and released them into the Glasgow sky.

This was the first time that Kevin had spent a long period working with women of this age group, and he was surprised how well they responded to his ideas and how well they all got along. Feeling that simple gestures of kindness mean a lot, Kevin arranged for the women to have makeovers at Mak Stylists in the Merchant City in Glasgow, followed by a meal that he prepared and cooked for them in his studio space at GoMA. He said:

'I thought nowadays that modern men thought about their partners, helped out about the house and shared the cooking and cleaning duties. How wrong was I! Then I remembered as a dumb teenager leaving dirty clothes and dishes behind me for my mother to pick up, complaining about the food and avoiding domestic responsibilities like the plague. How could I even begin to make amends for mankind's disregard of the opposite sex? Well, I suppose solo cooking for eight hours on a Sunday and making three quiches for the first time is a start!'

An exhibition of work from the project was displayed in GoMA between 18 July and 26 September 2005, running alongside the *Barbara Kruger* installation.

The Schools and Events Programme

GoMA's E&A team hosted a diverse programme of talks, tours, performances and workshops, with over 800 children, young people and adults taking part. Barbara Kruger's exhibition provided us with scope to explore the issue of domestic violence and art in ways that were new to us, such as through music, writing, drama and women's self-defence workshops. We also included descriptive tours and workshops specifically designed for visitors with a hearing or visual impairment. All of these events were free.

The team worked with freelance artists to deliver these programmes, and this enabled us to enrich the quality and range of what was on offer. We were able to support local practitioners while providing valuable skills-sharing and learning experiences for GoMA's education team.

Throughout the exhibition, our colleagues in the Library at GoMA provided a display of books, catalogues and information relating to the programme and ran a series of author readings.

We also ran community group workshops targeted at women's organizations across Glasgow and Scotland. The groups were offered the opportunity to visit GoMA for the day, take part in an exhibition tour and in practical art workshops tailored specifically to their needs. Through these workshops we were

Women from Glasgow Women's Library release balloons from their booth outside GoMA.

Self-defence workshop in the gallery space.

Participants at a community group workshop.

Children's dance workshop at GoMA during *Rule of Thumb*.

able to reach new and diverse groups, and to introduce them to GoMA and our work there.

We developed workshops for both primary and secondary level pupils, in partnership with Glasgow City Council's Education Services. These brought together the theme of citizenship with graphic art while encouraging the youngsters to explore Kruger's work and express their opinions on the issues raised. We had a keen response to these, especially from primary schools, and over 350 pupils from 17 schools attended. We also developed a set of teacher's notes, with pre-visit activities, discussion topics around the issue and the art, and resources for further work as well as guidance for those running self-guided visits.

What we learnt from delivering the programme

Our first artist-in-residency was a huge learning experience for us, but it was a success. We continue to host annual residencies, building on the knowledge we gained from this project with Kevin Reid, and now offer longer residencies of up to six months on a part-time basis. This allows the artist more time to research, more time to

develop meaningful relationships with group members, and more time to realize the ideas that come out of the project.

From delivering the 2005 social justice education programme we learnt that:

- further lead-in and research time is needed for the E&A team to explore the topic. The issues involved are sensitive, and the team are in the frontline delivering workshops.

- training and support for staff are needed. We found that providing meetings with support workers and delivering workshops in pairs worked best, as many groups found the exhibition emotionally overpowering.

- we should set up a separate advisory board with an education remit. That way, the role of E&A within the social justice programmes can be discussed and explored further with education specialists.

The *Blind Faith* programme in 2007, focusing on sectarianism and related issues, required a different approach and sensitivity, but we adapted and developed the education programme drawing on the knowledge we gained from *Rule of Thumb*. We consulted with education specialists when we were devising the schools programme, and marketed it direct to teachers. This resulted in a high uptake of the accompanying schools workshops. And again, the advisory board played an important role in the development and content of the Response Space, which doubled in size. The biggest development in 2007's programme was a six-month-long joint artist and writer in residency – the results of this will be displayed in Gallery 3 in December 2007.